Muirhead Bone
Oct. '78

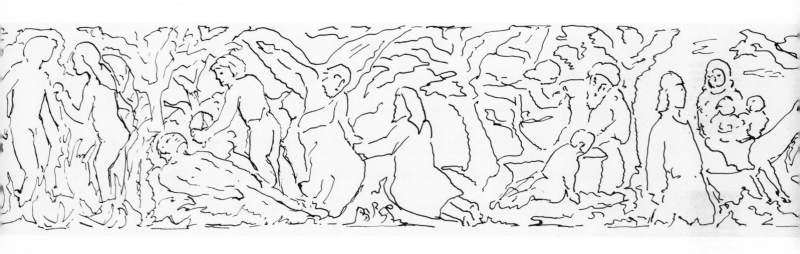

# Mortimer Borne

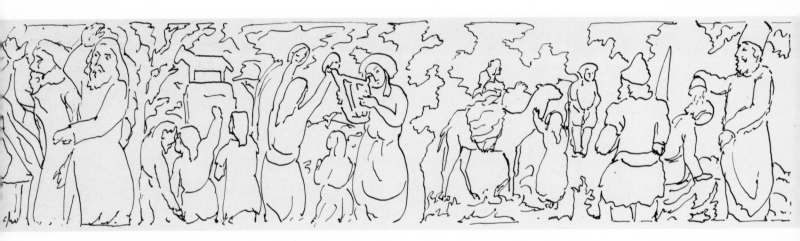

# The Visual Bible

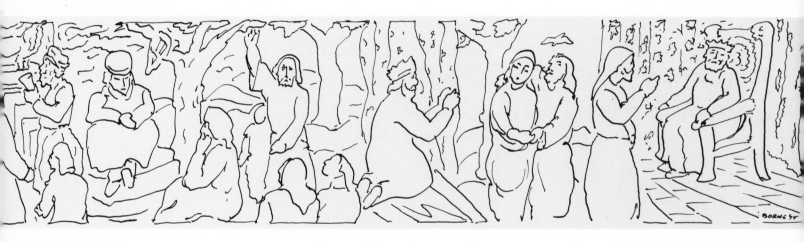

## Ninety-two Drawings

ABARIS BOOKS

New York

First published by Abaris Books, Inc.
200 Fifth Avenue, New York, N.Y. 10010

Printed in the U.S.A.
ISBN 0-913870-15-3
LC: 76-10438

# CONTENTS

|  |  |  | Facing Page |
|---|---|---|---|
| **Genesis** | 1. | Adam and Eve | 8 |
|  | 2. | Cain Slays Abel | 10 |
|  | 3. | Noah's Ark | 12 |
|  | 4. | Tower of Babel | 14 |
|  | 5. | Abraham and Sarah Journey Toward Kadesh and Shur | 16 |
|  | 6. | Abraham Dismisses Hagar | 18 |
|  | 7. | Sacrifice of Isaac | 20 |
|  | 8. | Isaac Blesses Jacob | 22 |
|  | 9. | Jacob's Ladder | 24 |
|  | 10. | Jacob Meets Rachel and Leah | 26 |
|  | 11. | Joseph Sold to the Ishmeelites | 28 |
|  | 12. | The Blessing of Ephraim and Manasseh | 30 |
|  | 13. | Death of Joseph | 32 |
| **Exodus** | 14. | Labors of the Hebrews | 34 |
|  | 15. | The Finding of Moses | 36 |
|  | 16. | Moses and Jethro's Seven Daughters | 38 |
|  | 17. | Moses and the Burning Bush | 40 |
|  | 18. | Moses and Family Journey to Egypt | 42 |
|  | 19. | The Frogs | 44 |
|  | 20. | Moses Before Pharaoh | 46 |
|  | 21. | Exodus from Egypt | 48 |
|  | 22. | Moses' Song of Victory | 50 |
|  | 23. | The Quails | 52 |
|  | 24. | The Raised Hands of Moses | 54 |
|  | 25. | Jethro Advises Moses in the Desert | 56 |
|  | 26. | Aaron | 58 |
|  | 27. | The Golden Calf | 60 |
|  | 28. | Moses and the Tablets | 62 |
|  | 29. | Moses Breaks the Tablets | 64 |
| **Leviticus** | 30. | Nadab and Abihu Destroyed by Fire | 66 |
| **Numbers** | 31. | Balaam and the Ass | 68 |
|  | 32. | Balaam Blesses Israel | 70 |
|  | 33. | Moses and Joshua Lead the Army | 72 |
| **Deuteronomy** | 34. | Death of Moses | 74 |
| **Joshua** | 35. | The Harlot Rahab Saves Joshua's Messengers | 76 |
|  | 36. | Five Kings Hanged | 78 |
| **Judges** | 37. | Samson Breaks the Pillars | 80 |
| **Ruth** | 38. | Ruth and Naomi | 82 |

|  |  |  | Facing Page |
|---|---|---|---|
| I Samuel | 39. | Samuel at Ramah | 84 |
|  | 40. | Samuel Anoints Saul | 86 |
|  | 41. | David Plays Before Saul | 88 |
|  | 42. | David and Goliath | 90 |
|  | 43. | Saul Has Triumphed Over Thousands, David Over Tens of Thousands | 92 |
|  | 44. | Jonathan Warns David | 94 |
|  | 45. | Death of Saul | 96 |
| II Samuel | 46. | David Laments the Death of Saul and Jonathan | 98 |
|  | 47. | David Spies Bath-sheba | 100 |
|  | 48. | David Mourneth Absolom | 102 |
| I Kings | 49. | Solomon's Judgment | 104 |
|  | 50. | This is Thy God, Oh Israel | 106 |
|  | 51. | Asa Sends the Treasures to Ben-hadad | 108 |
|  | 52. | Worship of Idols | 110 |
|  | 53. | Ben-hadad and His Allies | 112 |
| II Kings | 54. | Elijah Carried to Heaven | 114 |
| I Chronicles | 55. | Hiram Sends Presents to David | 116 |
| II Chronicles | 56. | Jehoshaphat Speaks to the People | 118 |
| Ezra | 57. | Delegation Meets Cyrus | 120 |
|  | 58. | Ezra Expounds the Law | 122 |
| Nehemiah | 59. | Artaxerxes and Nehemiah | 124 |
|  | 60. | The Armed Builders | 126 |
| Esther | 61. | Esther and Ahasuerus | 128 |
|  | 62. | The Triumph of Mordecai | 130 |
| Job | 63. | Job's Wife Reproves | 132 |
|  | 64. | Job and His Friends | 134 |
|  | 65. | And Job Cursed His Day | 136 |
| Psalms | 66. | Dream of Jerusalem | 138 |
|  | 67. | By the Rivers of Babylon | 140 |
| Proverbs | 68. | At the Window of My House | 142 |
|  | 69. | Three Things that are Wonderful, Yea Four | 144 |
| Ecclesiastes | 70. | Vanity of Vanities | 146 |
| Solomon's Song | 71. | Awake Not My Love | 148 |
|  | 72. | Many Waters Cannot Quench Love | 150 |
| Isaiah | 73. | Swords into Ploughshares | 152 |
|  | 74. | The Peaceable Kingdom | 154 |
| Jeremiah | 75. | Jeremiah Bound | 156 |
|  | 76. | Jeremiah Dictates to Baruch | 158 |
| Lamentations | 77. | The Mourners | 160 |
| Ezekiel | 78. | Vision of Ezekiel | 162 |
| Daniel | 79. | Alexander Pays Homage to God | 164 |
| Hosea | 80. | So I Bought Her For 15 Pieces of Silver | 166 |
| Joel | 81. | The Vision of Joel | 168 |
| Amos | 82. | Amos Preaches | 170 |
| Obadiah | 83. | The Vision of Obadiah | 172 |
| Jonah | 84. | Jonah Preaches in Nineveh | 174 |
|  | 85. | Jonah Cast Into the Sea | 176 |
| Micah | 86. | The Prophesy of Micah | 178 |
| Nahum | 87. | Woe to Nineveh, the Bloody City | 180 |
| Habakkuk | 88. | Vision of Habakkuk | 182 |
| Zephaniah | 89. | Prophesy of Zephaniah | 184 |
| Haggai | 90. | Prophesy of Haggai | 186 |
| Zechariah | 91. | Prophesy of Peace | 188 |
| Malachi | 92. | Malachi Reproves the Priests | 190 |

# INTRODUCTION

A Bible lies before me. I open it with reverence and expectation. The pages are old and subtly stained. One cannot say whether the stains were caused by tears or sweat; darker spots might have been caused by blood. I read the words, "In the beginning. . . ." I try to get the sensation of being present at the beginning.

"And the earth was waste and void." Was it only the earth that was waste and void? "And God made the firmament" — I thought about the rational theories I have read: How a blob of gas coagulated into stars and smaller blobs detached themselves from the stars and became planets like our earth. But where was the beginning? There was no way to reach that point, neither with logic nor with introspection. That is really not so surprising, since even in my consciousness I could find no true beginning. My consciousness apparently evolved out of a void and in a void; it is not possible to descry a beginning, no more than the first letter on this page is really the beginning.

I would like to portray graphically my impressions of the "beginning" as I read the Bible. I find that impossible, so I do the next best thing. I draw a spiral and place within it the appearance of an eye, the all-seeing eye, the presence that permeates all thought and seeing, all sensing and all believing; and I scatter around the appearance of animal forms that I can identify with, primarily because they move about much as I do. Those other things about me, like the stones and earth and even the trees, move at so slow a pace that I place them in a separate category from myself and call them "inanimate" — and yet I sense that all creation about me echoes within me one overriding quality, namely, Rhythm. I try to convey the sense of rhythm. While my eyes scan the lines on the pages, I become conscious of yet another quality that supersedes all other qualities, namely, Time. Not the artificial symbols of day and night or the sequence of seasons, or the creeping shadow on the sun dial, or the sequence of leaves on the calendar, but *actual* time that has no beginning and no foreseeable end.

How does one relate the momentous happenings in the history of a people that sparked the idea of one God concerned with the welfare of all peoples on earth? How does one translate thought into graphic form? How can one translate the abstract thought that will focus upon certain individuals, the actors in the ongoing dramatic performance?

I decided to limit myself to line drawings with which to depict my mental reconstructions of the events and the actors in the Bible. God has endowed man with imagination and on the wings of that imagination I can make excursions in the direction of the beginning and in the direction of the end.

Mortimer Borne
Nyack, New York 1976

Now the serpent was more subtil than any beast of the field which the Lord God had made. And he said unto the woman, Yea, hath God said, Ye shall not eat of every tree of the garden? And the woman said unto the serpent, We may eat of the fruit of the trees of the garden: but of the fruit of the tree which is in the midst of the garden, God hath said, Ye shall not eat of it, neither shall ye touch it, lest ye die. And the serpent said unto the woman, Ye shall not surely die: for God doth know that in the day ye eat thereof, then your eyes shall be opened, and ye shall be as gods, knowing good and evil.

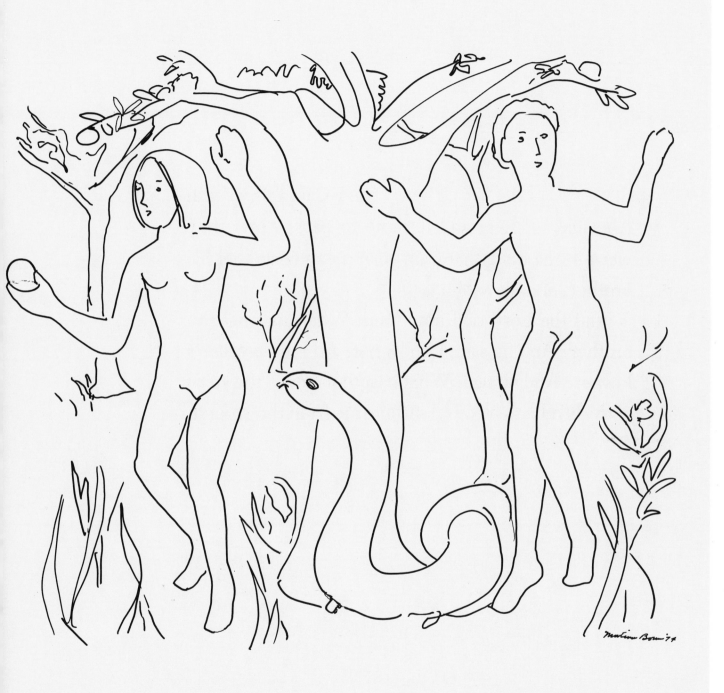

And Cain talked with Abel his brother: and it came to pass, when they were in the field, that Cain rose up against Abel his brother, and slew him.

And the Lord said unto Cain, Where is Abel thy brother? And he said, I know not: am I my brother's keeper? And he said, What hast thou done? the voice of thy brother's blood crieth unto me from the ground.

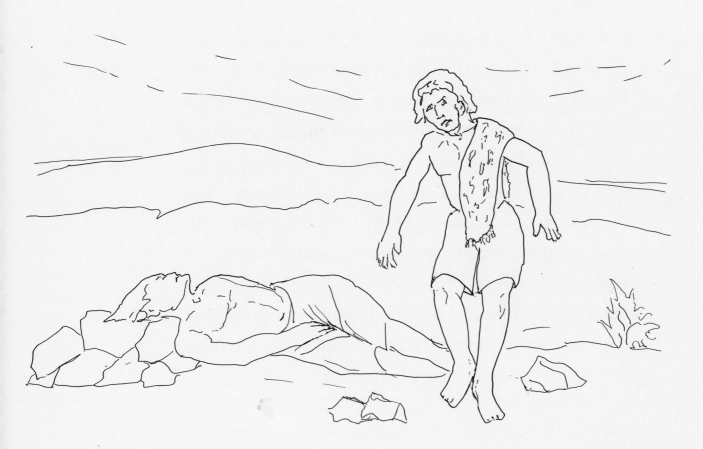

AND the Lord said unto Noah, Come thou and all thy house into the ark; for thee have I seen righteous before me in this generation. Of every clean beast thou shalt take to thee by sevens, the male and his female: and of beasts that are not clean by two, the male and his female. Of fowls also of the air by sevens, the male and the female; to keep seed alive upon the face of all the earth. For yet seven days, and I will cause it to rain upon the earth forty days and forty nights; and every living substance that I have made will I destroy from off the face of the earth. And Noah did according unto all that the Lord commanded him. And Noah was six hundred years old when the flood of waters was upon the earth.

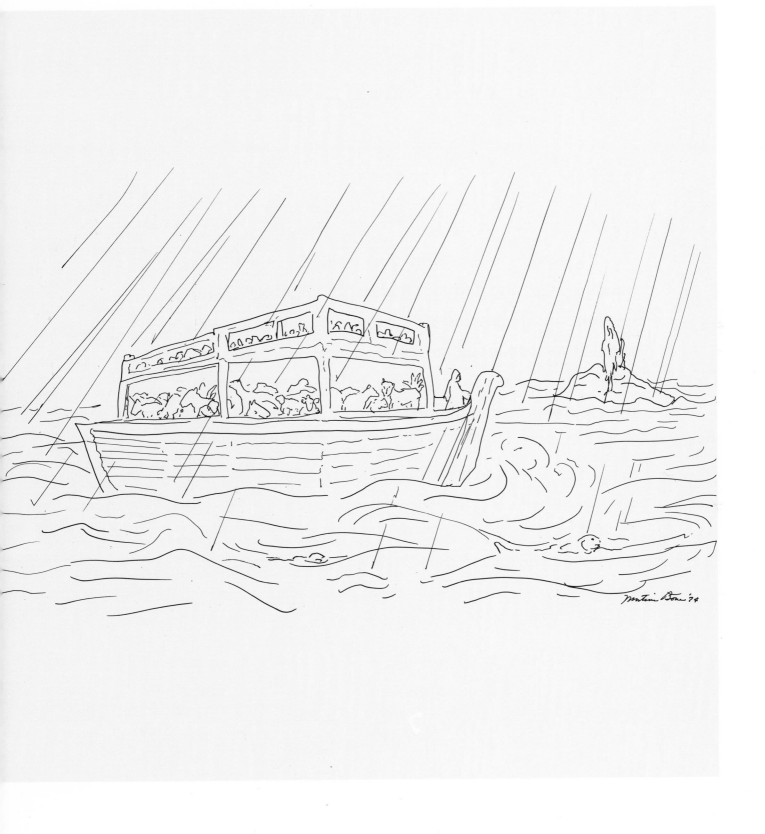

And they said, Go to, let us build us a city and a tower, whose top may reach unto heaven; and let us make us a name, lest we be scattered abroad upon the face of the whole earth. And the Lord came down to see the city and the tower, which the children of men builded.

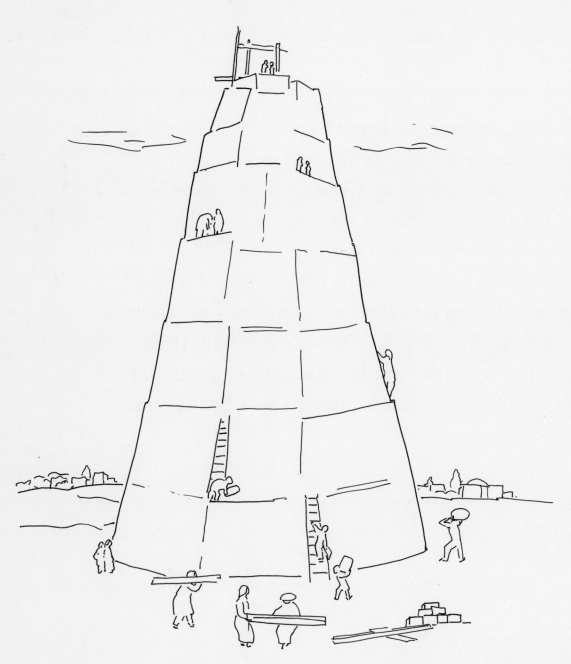

AND Abraham journeyed from thence toward the south country, and dwelled between Kadesh and Shur, and sojourned in Gerar. And Abraham said of Sarah his wife, She is my sister: and Abimelech king of Gerar sent, and took Sarah. But God came to Abimelech in a dream by night, and said to him, Behold, thou art but a dead man, for the woman which thou hast taken; for she is a man's wife. But Abimelech had not come near her: and he said, Lord, wilt thou slay also a righteous nation? Said he not unto me, She is my sister?

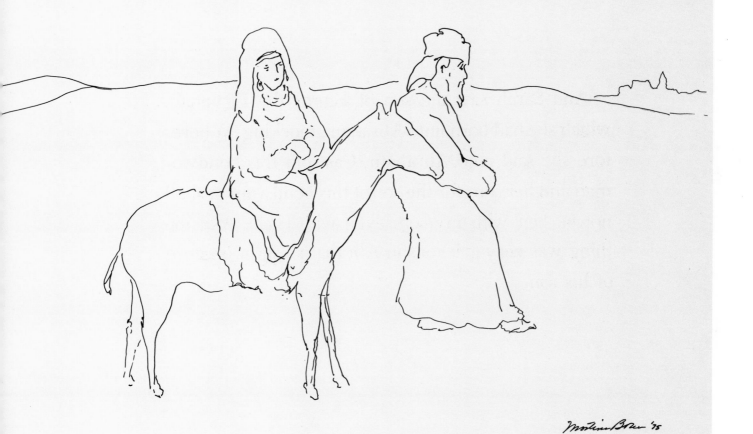

And Sarah saw the son of Hagar the Egyptian, which she had born unto Abraham, mocking. Wherefore she said unto Abraham, Cast out this bondwoman and her son: for the son of this bondwoman shall not be heir with my son, even with Isaac. And the thing was very grievous in Abraham's sight because of his son.

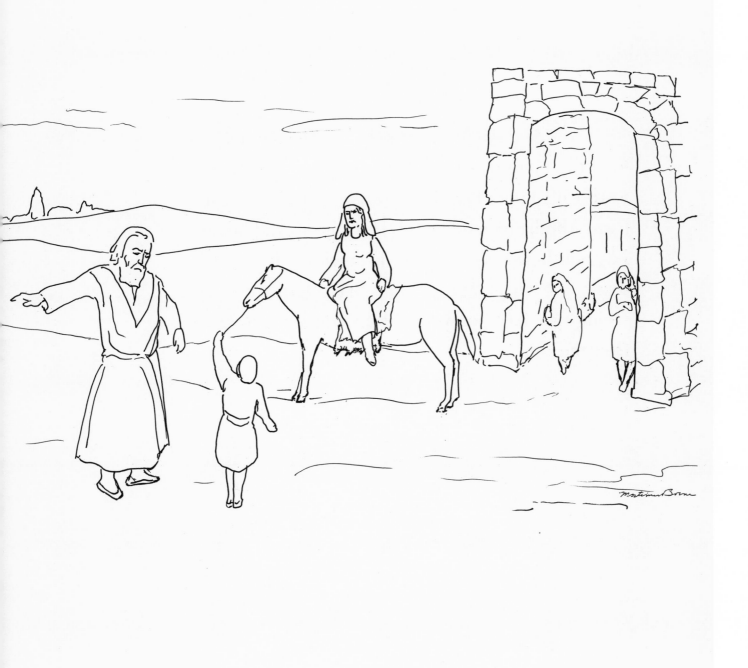

And Abraham stretched forth his hand, and took the knife to slay his son. And the angel of the Lord called unto him out of heaven, and said, Abraham, Abraham: and he said, Here am I. And he said, Lay not thine hand upon the lad, neither do thou any thing unto him: for now I know that thou fearest God, seeing thou hast not withheld thy son, thine only son from me.

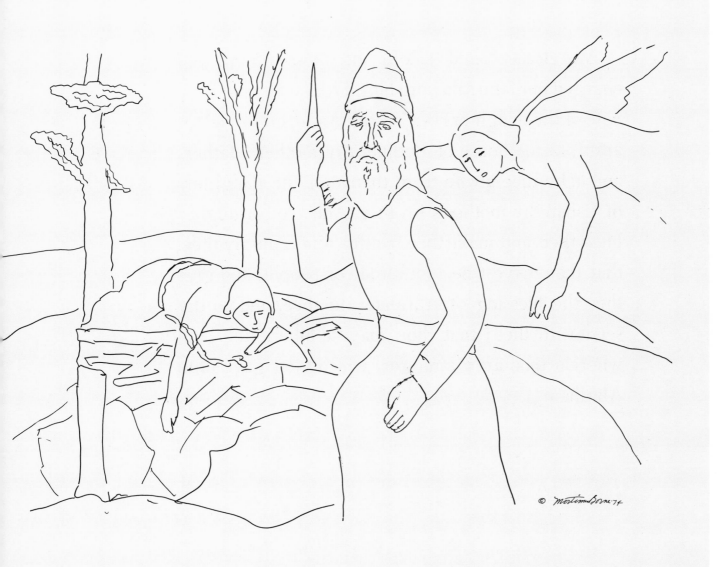

AND Isaac called Jacob, and blessed him, and charged him, and said unto him, Thou shalt not take a wife of the daughters of Canaan. Arise, go to Padan-aram, to the house of Bethuel thy mother's father; and take thee a wife from thence of the daughters of Laban thy mother's brother. And God Almighty bless thee, and make thee fruitful, and multiply thee, that thou mayest be a multitude of people; and give thee the blessing of Abraham, to thee, and to thy seed with thee; that thou mayest inherit the land wherein thou art a stranger, which God gave unto Abraham.

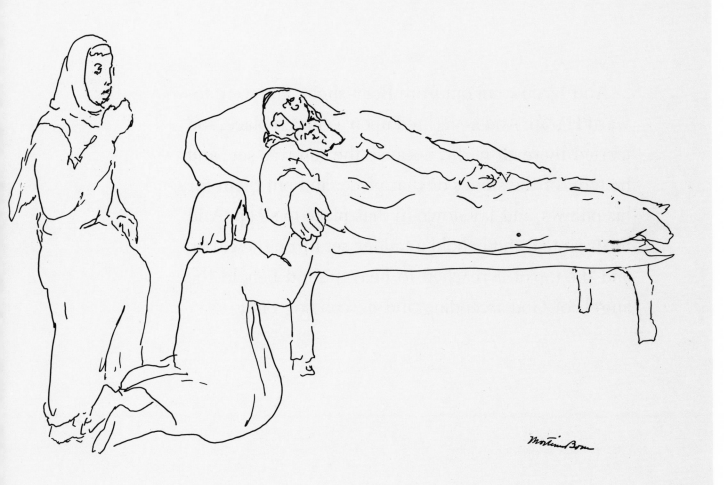

And Jacob went out from Beer-sheba, and went toward Haran. And he lighted upon a certain place, and tarried there all night, because the sun was set; and he took of the stones of that place, and put them for his pillows, and lay down in that place to sleep. And he dreamed, and behold a ladder set up on the earth, and the top of it reached to heaven: and behold the angels of God ascending and descending on it.

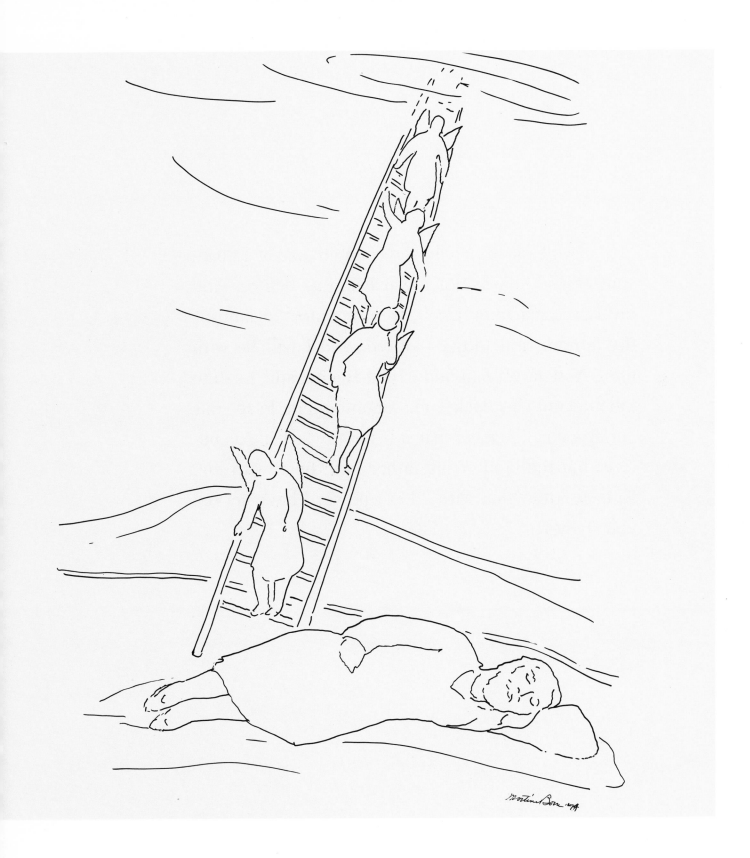

And Jacob beheld the countenance of Laban, and, behold, it was not toward him as before. And the Lord said unto Jacob, Return unto the land of thy fathers, and to thy kindred; and I will be with thee. And Jacob sent and called Rachel and Leah to the field unto his flock, and said unto them, I see your father's countenance, that it is not toward me as before; but the God of my father hath been with me. And ye know that with all my power I have served your father.

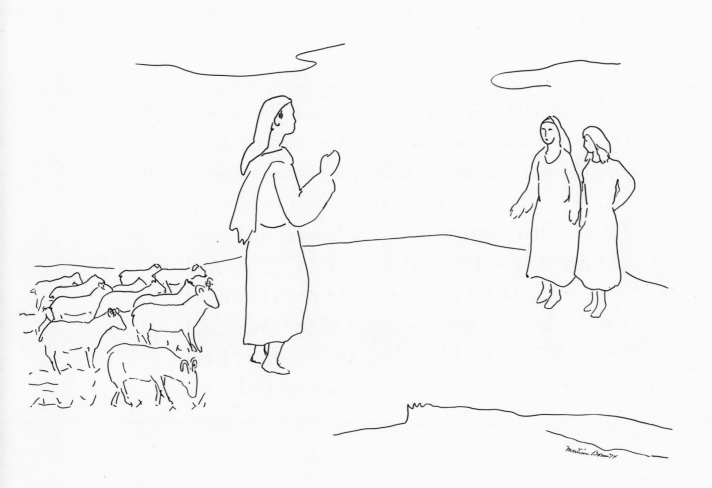

And it came to pass, when Joseph was come unto his brethren, that they stript Joseph out of his coat, his coat of many colours that was on him; and they took him, and cast him into a pit: and the pit was empty, there was no water in it. And they sat down to eat bread: and they lifted up their eyes and looked, and, behold, a company of Ishmeelites came from Gilead with their camels bearing spicery and balm and myrrh, going to carry it down to Egypt. And Judah said unto his brethren, What profit is it if we slay our brother, and conceal his blood? Come, and let us sell him to the Ishmeelites, and let not our hand be upon him; for he is our brother and our flesh.

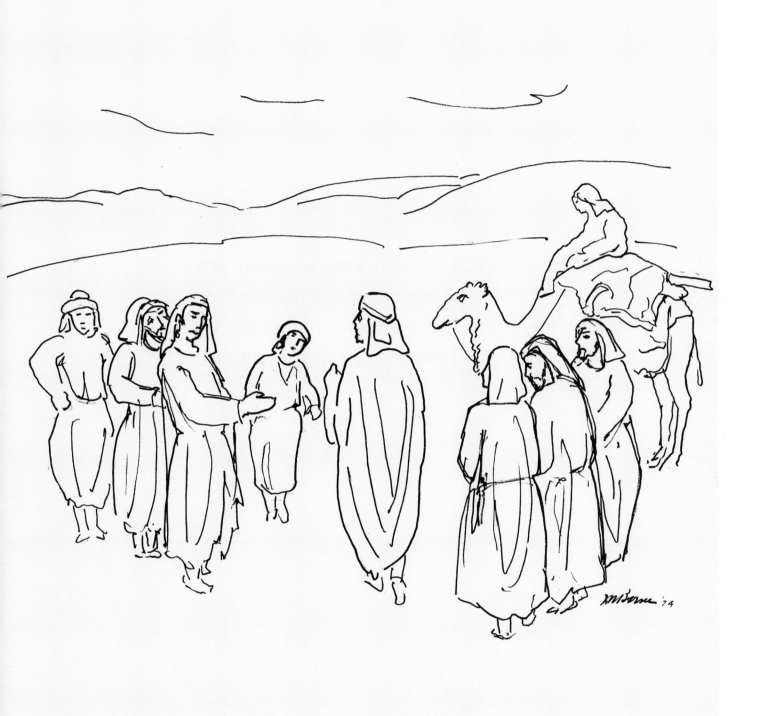

And Israel beheld Joseph's sons, and said, Who are these? And Joseph said unto his father, They are my sons, whom God hath given me in this place. And he said, Bring them, I pray thee, unto me, and I will bless them.

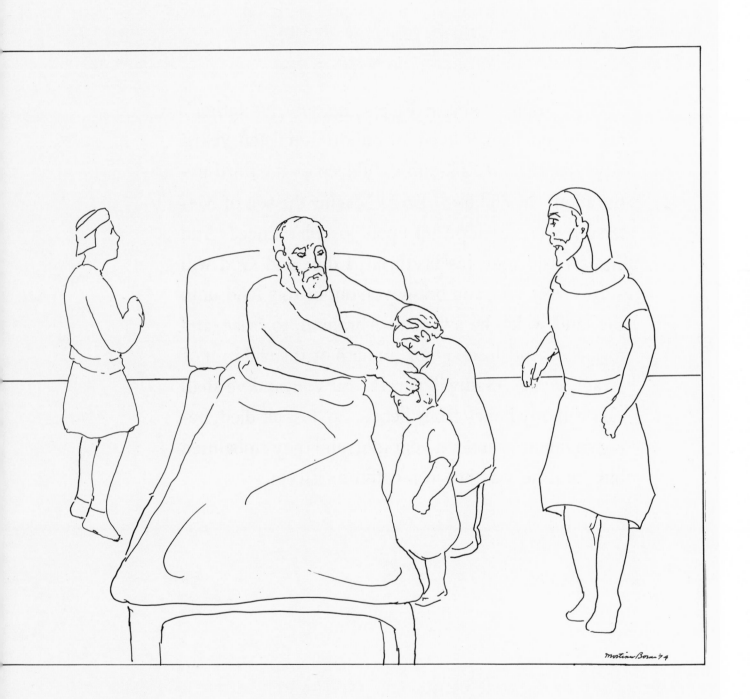

And Joseph dwelt in Egypt, he, and his father's house: and Joseph lived an hundred and ten years. And Joseph saw Ephraim's children of the third generation: the children also of Machir the son of Manasseh were brought up upon Joseph's knees. And Joseph said unto his brethren, I die: and God will surely visit you, and bring you out of this land unto the land which he sware to Abraham, to Isaac, and to Jacob. And Joseph took an oath of the children of Israel, saying, God will surely visit you, and ye shall carry up my bones from hence. So Joseph died, being an hundred and ten years old: and they embalmed him, and he was put in a coffin in Egypt.

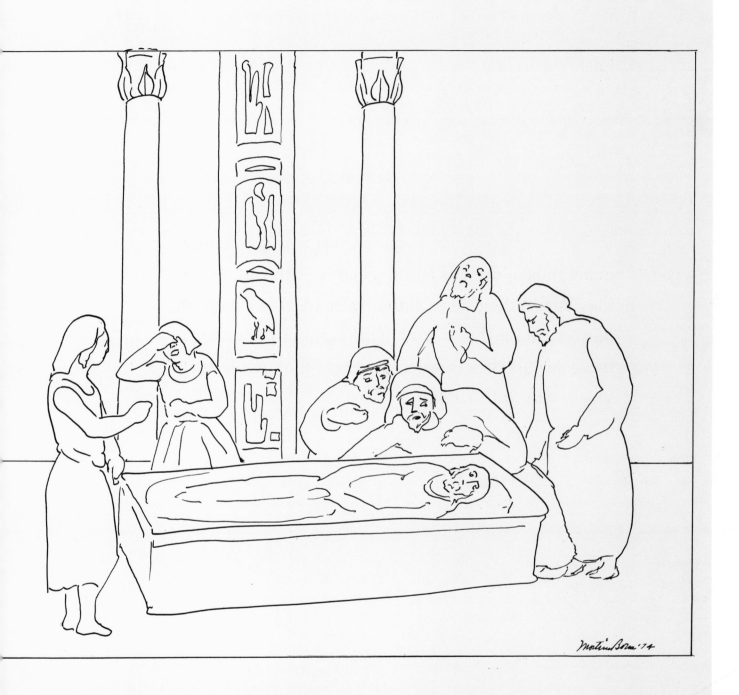

And the Egyptians made the children of Israel to serve with rigour: and they made their lives bitter with hard bondage, in morter, and in brick, and in all manner of service in the field: all their service, wherein they made them serve, was with rigour.

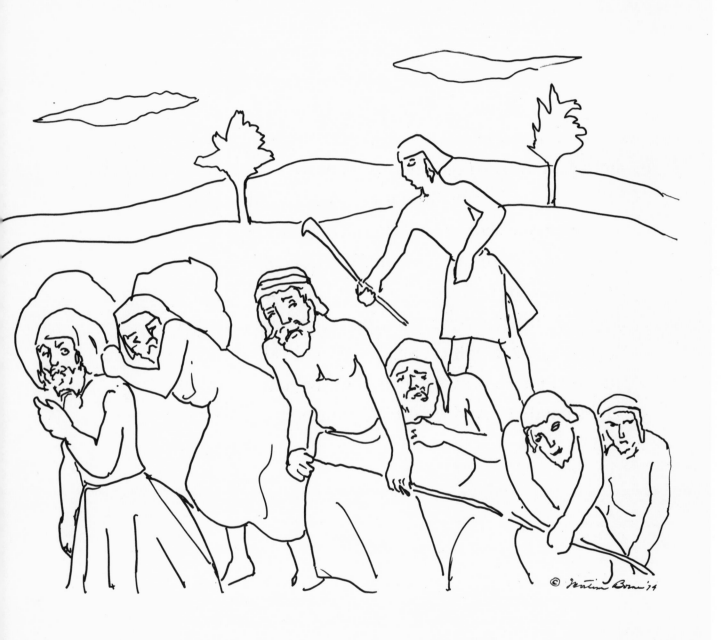

And the daughter of Pharaoh came down to wash herself at the river; and her maidens walked along by the river's side; and when she saw the ark among the flags, she sent her maid to fetch it. And when she had opened it, she saw the child: and, behold, the babe wept. And she had compassion on him, and said, This is one of the Hebrews' children. Then said his sister to Pharaoh's daughter, Shall I go and call to thee a nurse of the Hebrew women, that she may nurse the child for thee? And Pharaoh's daughter said to her, Go.

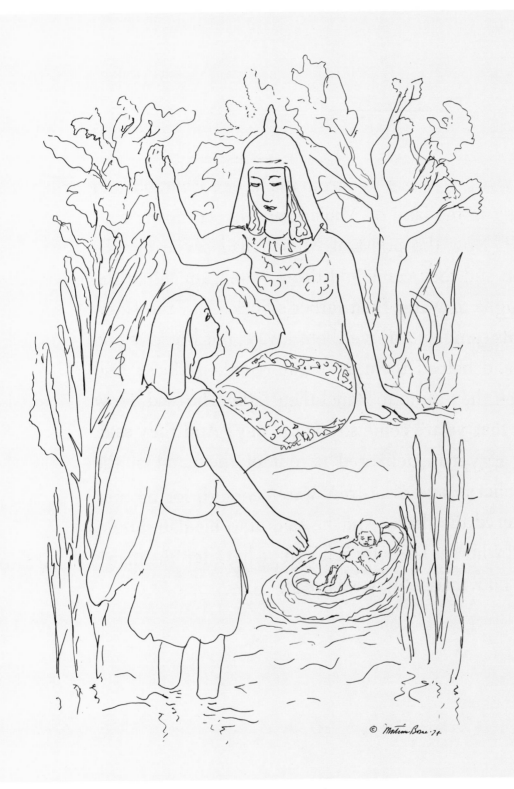

Moses fled from the face of Pharaoh, and dwelt in the land of Midian: and he sat down by a well. Now the priest of Midian had seven daughters: and they came and drew water, and filled the troughs to water their father's flock. And the shepherds came and drove them away: but Moses stood up and helped them, and watered their flock. And when they came to Reuel their father, he said, How is it that ye are come so soon to day? And they said, An Egyptian delivered us out of the hand of the shepherds, and also drew water enough for us, and watered the flock. And he said unto his daughters, And where is he? why is it that ye have left the man? call him, that he may eat bread.

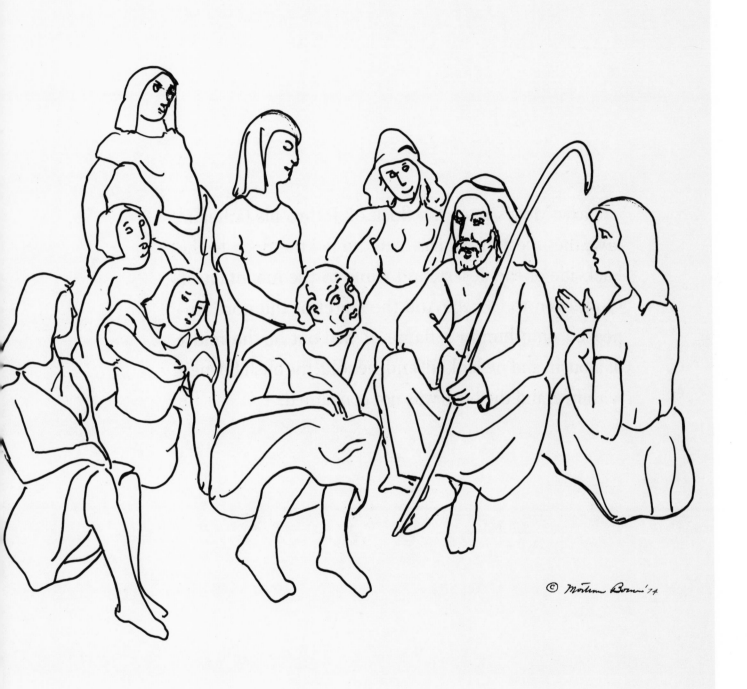

Now Moses kept the flock of Jethro his father in law, the priest of Midian: and he led the flock to the backside of the desert, and came to the mountain of God, even to Horeb. And the angel of the Lord appeared unto him in a flame of fire out of the midst of a bush: and he looked, and, behold, the bush burned with fire, and the bush was not consumed.

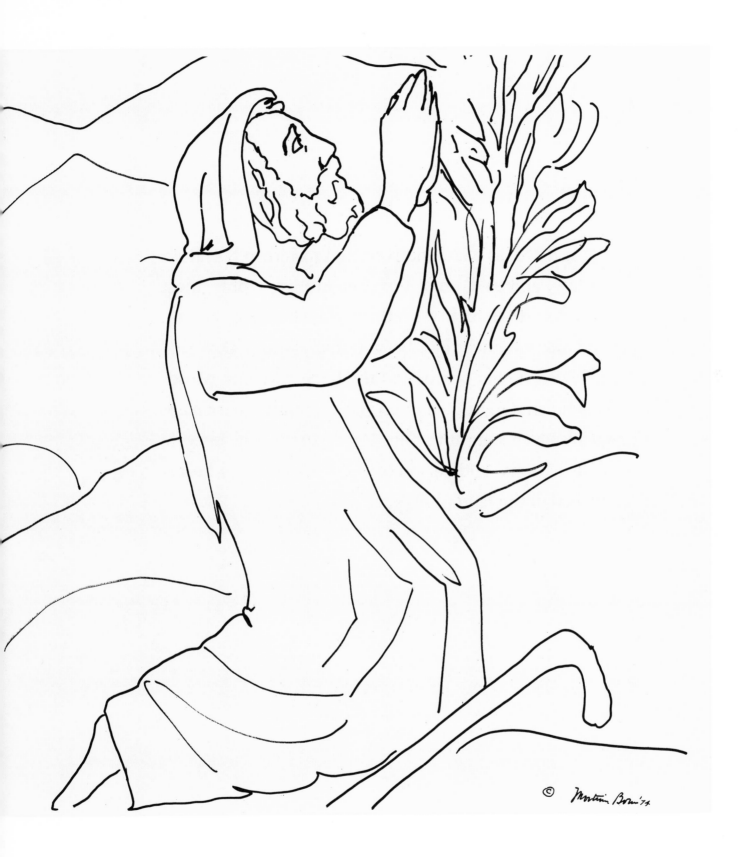

And Moses went and returned to Jethro his father in law, and said unto him, Let me go, I pray thee, and return unto my brethren which are in Egypt, and see whether they be yet alive. And Jethro said to Moses, Go in peace. And the Lord said unto Moses in Midian, Go, return into Egypt: for all the men are dead which sought thy life. And Moses took his wife and his sons, and set them upon an ass, and he returned to the land of Egypt.

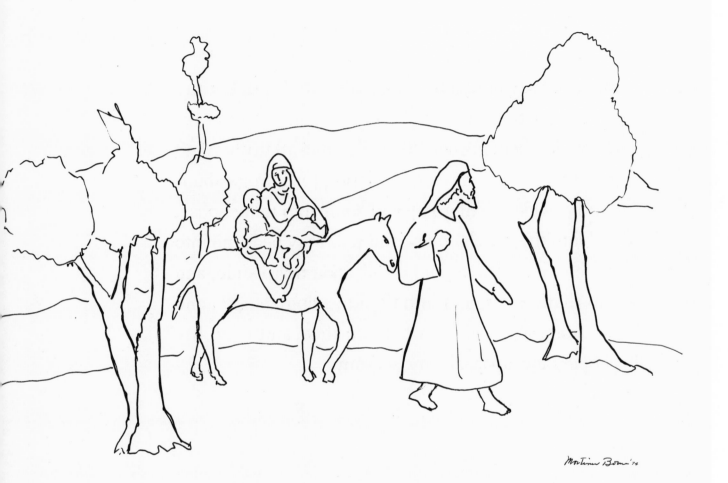

AND the Lord spake unto Moses, Go unto Pharaoh, and say unto him, Thus saith the Lord, Let my people go, that they may serve me. And if thou refuse to let them go, behold, I will smite all thy borders with frogs: and the river shall bring forth frogs abundantly, which shall go up and come into thine house, and into thy bedchamber, and upon thy bed, and into the house of thy servants, and upon thy people, and into thine ovens, and into thy kneadingtroughs: and the frogs shall come up both on thee, and upon thy people, and upon all thy servants.

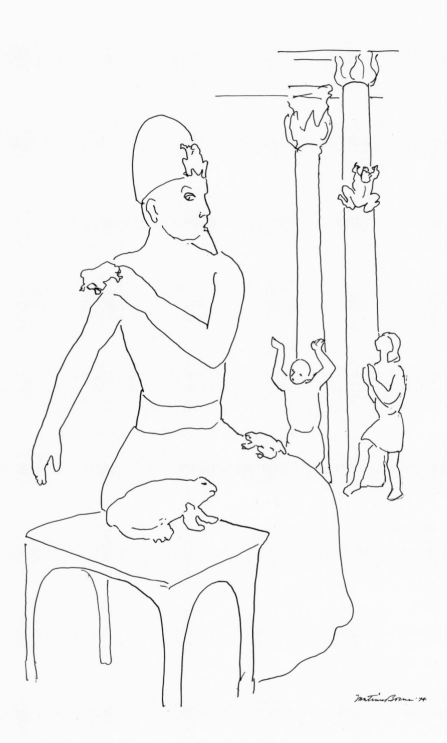

And the Lord said unto Moses, Rise up early in the morning, and stand before Pharaoh; lo, he cometh forth to the water; and say unto him, Thus saith the Lord, Let my people go, that they may serve me. Else, if thou wilt not let my people go, behold, I will send swarms of flies upon thee, and upon thy servants, and upon thy people, and into thy houses: and the houses of the Egyptians shall be full of swarms of flies, and also the ground whereon they are. And I will sever in that day the land of Goshen, in which my people dwell, that no swarms of flies shall be there; to the end thou mayest know that I am the Lord in the midst of the earth.

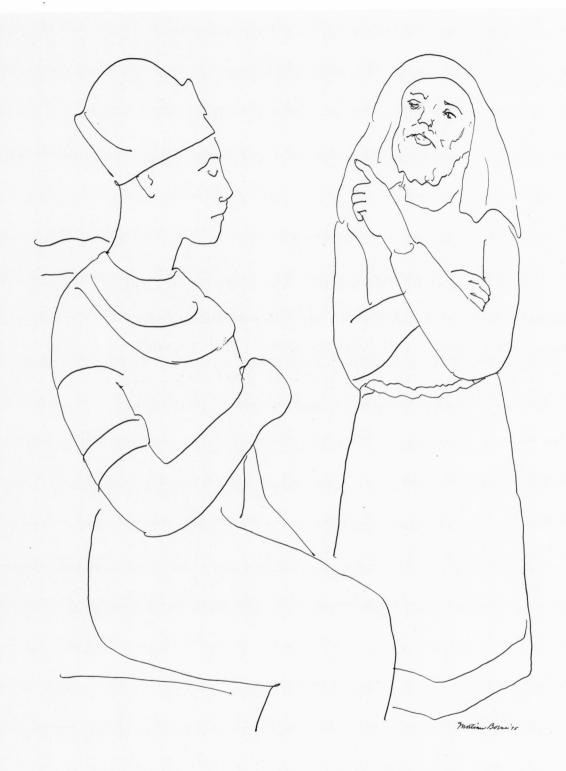

And he called for Moses and Aaron by night, and said, Rise up, and get you forth from among my people, both ye and the children of Israel; and go, serve the Lord, as ye have said. Also take your flocks and your herds, as ye have said, and be gone; and bless me also.

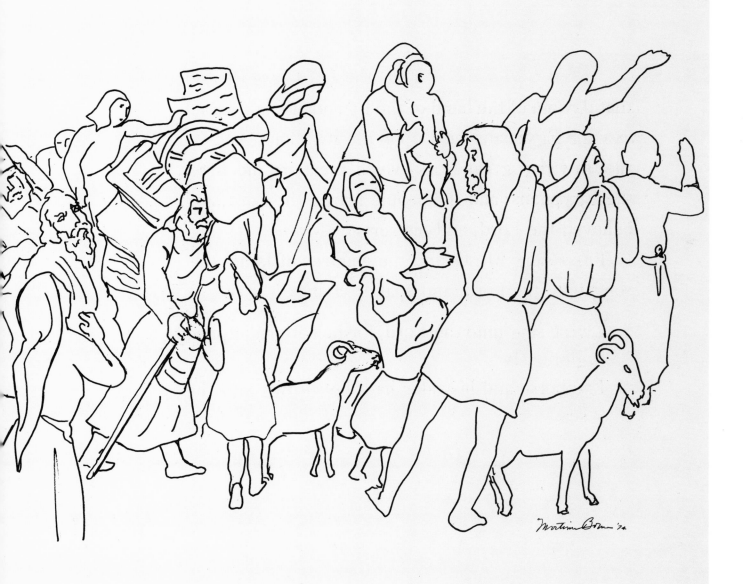

Thus the Lord saved Israel that day out of the hand of the Egyptians; and Israel saw the Egyptians dead upon the sea shore. And Israel saw that great work which the Lord did upon the Egyptians: and the people feared the Lord, and believed the Lord, and his servant Moses.

THEN sang Moses and the children of Israel this song unto the Lord, and spake, saying,

I WILL sing unto the Lord, for he hath triumphed gloriously:
The horse and his rider hath he thrown into the sea.

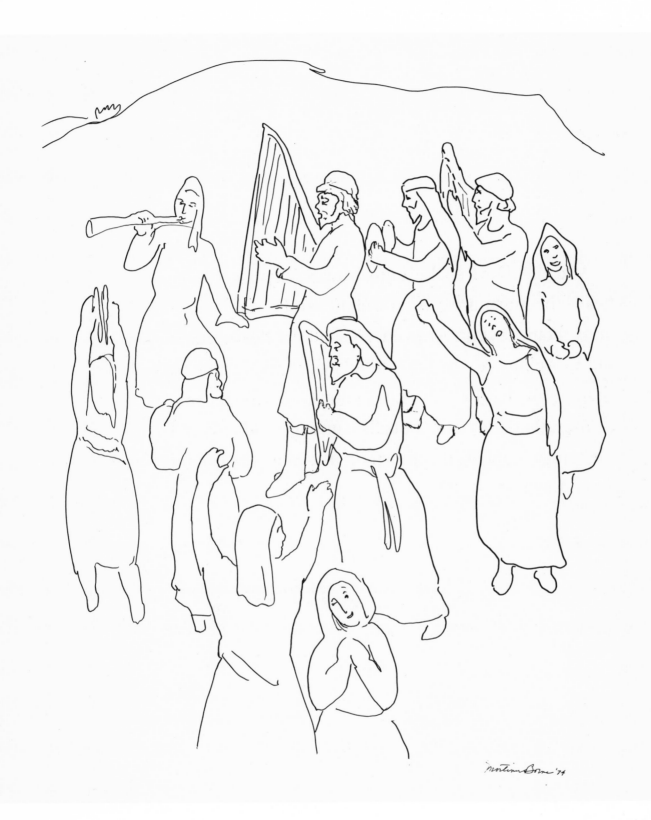

And the Lord spake unto Moses, saying, I have heard the murmurings of the children of Israel: speak unto them, saying, At even ye shall eat flesh, and in the morning ye shall be filled with bread; and ye shall know that I am the Lord your God. And it came to pass, that at even the quails came up, and covered the camp: and in the morning the dew lay round about the host.

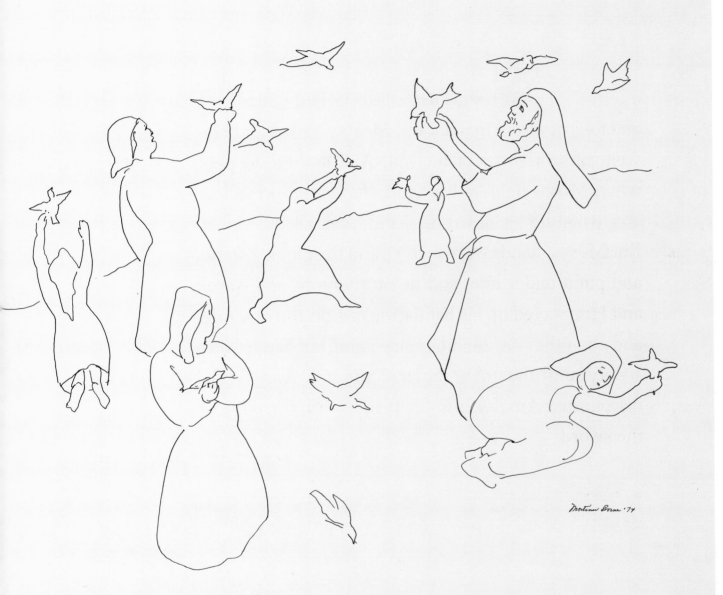

So Joshua did as Moses had said to him, and fought with Amalek: and Moses, Aaron, and Hur went up to the top of the hill. And it came to pass, when Moses held up his hand, that Israel prevailed: and when he let down his hand, Amalek prevailed. But Moses' hands were heavy; and they took a stone, and put it under him, and he sat thereon; and Aaron and Hur stayed up his hands, the one on the one side, and the other on the other side; and his hands were steady until the going down of the sun. And Joshua discomfited Amalek and his people with the edge of the sword.

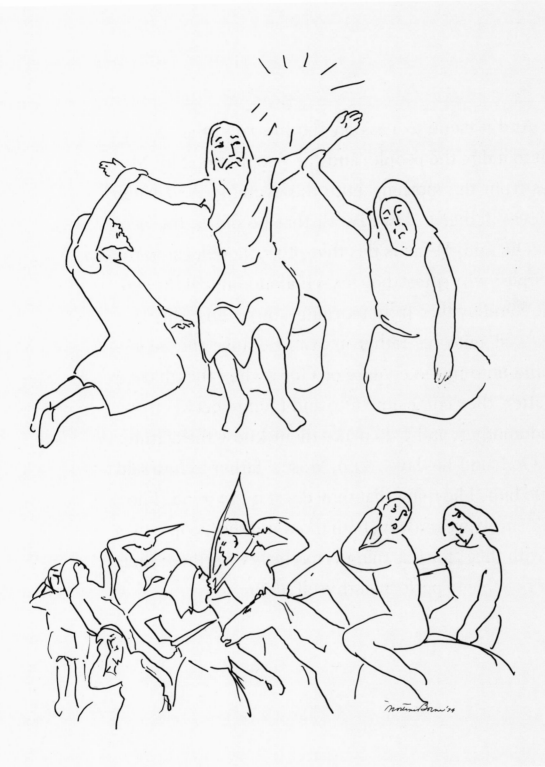

And it came to pass on the morrow, that Moses sat to judge the people: and the people stood by Moses from the morning unto the evening. And when Moses' father in law saw all that he did to the people, he said, What is this thing that thou doest to the people? why sittest thou thyself alone, and all the people stand by thee from morning unto even? And Moses said unto his father in law, Because the people come unto me to enquire of God: when they have a matter, they come unto me; and I judge between one and another, and I do make them know the statutes of God, and his laws. And Moses' father in law said unto him, The thing that thou doest is not good. Thou wilt surely wear away, both thou, and this people that is with thee: for this thing is too heavy for thee; thou art not able to perform it thyself alone.

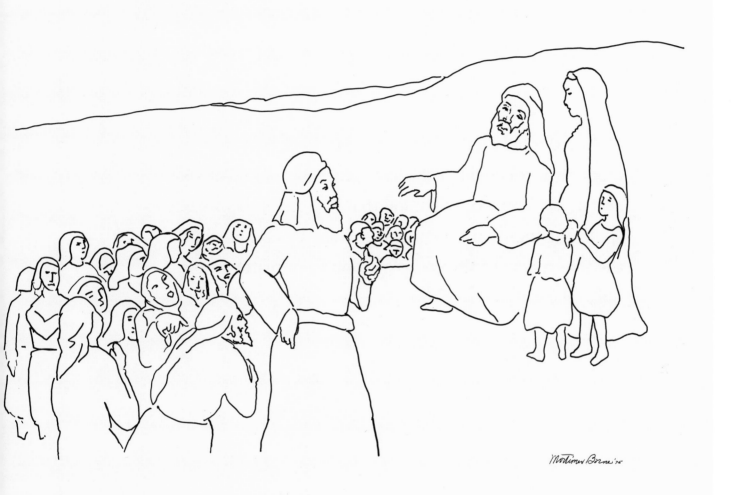

And the holy garments of Aaron shall be his sons' after him, to be anointed therein, and to be consecrated in them. And that son that is priest in his stead shall put them on seven days, when he cometh into the tabernacle of the congregation to minister in the holy place.

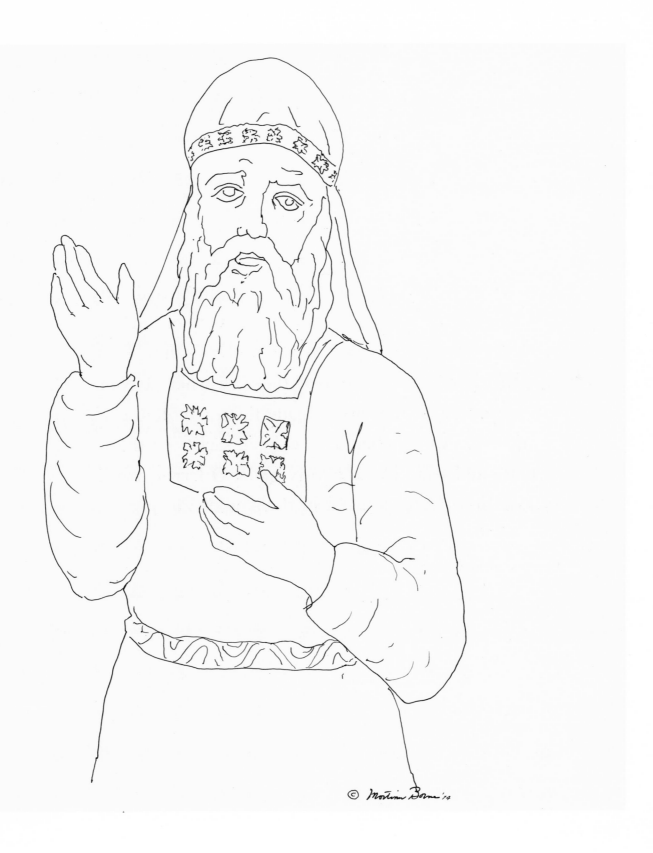

And the Lord said unto Moses, Go, get thee down; for thy people, which thou broughtest out of the land of Egypt, have corrupted themselves: they have turned aside quickly out of the way which I commanded them: they have made them a molten calf, and have worshipped it, and have sacrificed thereunto, and said, These be thy gods, O Israel, which have brought thee up out of the land of Egypt.

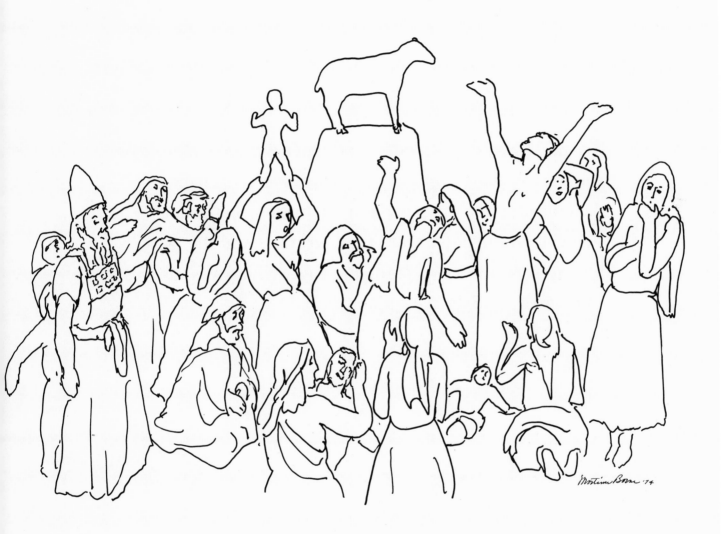

And Moses turned, and went down from the mount, and the two tables of the testimony were in his hand: the tables were written on both their sides; on the one side and on the other were they written. And the tables were the work of God, and the writing was the writing of God, graven upon the tables.

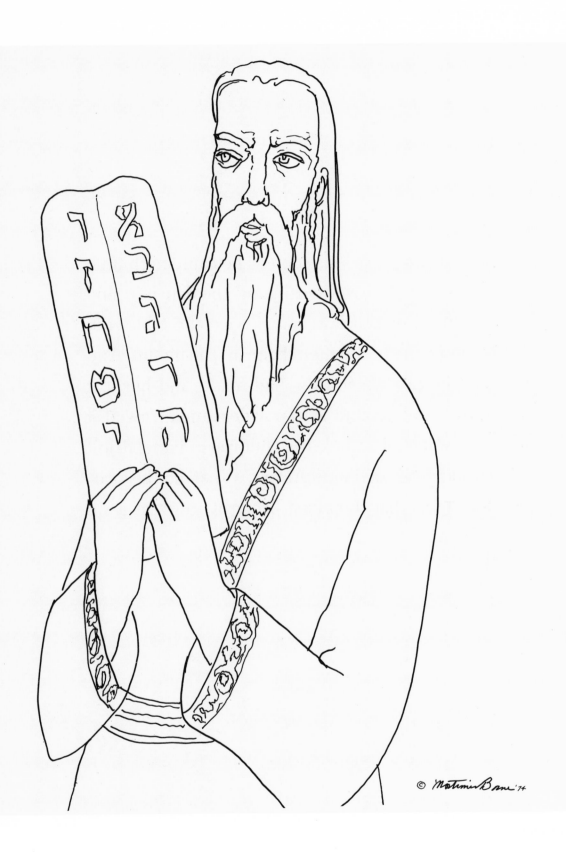

And it came to pass, as soon as he came nigh unto the camp, that he saw the calf, and the dancing: and Moses' anger waxed hot, and he cast the tables out of his hands, and brake them beneath the mount. And he took the calf which they had made, and burnt it in the fire, and ground it to powder, and strawed it upon the water, and made the children of Israel drink of it. And Moses said unto Aaron, What did this people unto thee, that thou hast brought so great a sin upon them?

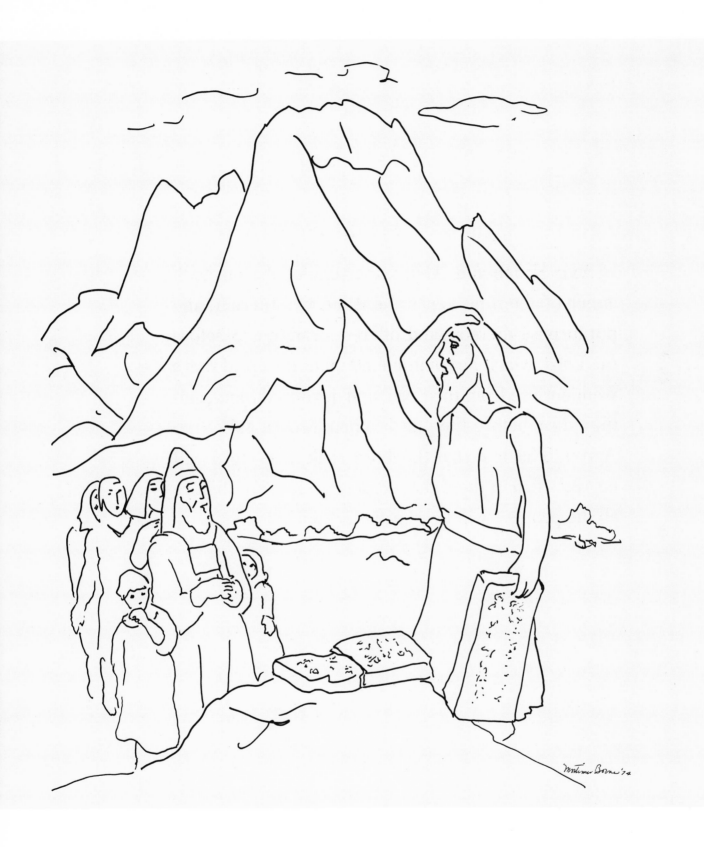

AND Nadab and Abihu, the sons of Aaron, took either of them his censer, and put fire therein, and put incense thereon, and offered strange fire before the Lord, which he commanded them not. And there went out fire from the Lord, and devoured them, and they died before the Lord. Then Moses said unto Aaron, This is it that the Lord spake, saying, I will be sanctified in them that come nigh me, and before all the people I will be glorified.

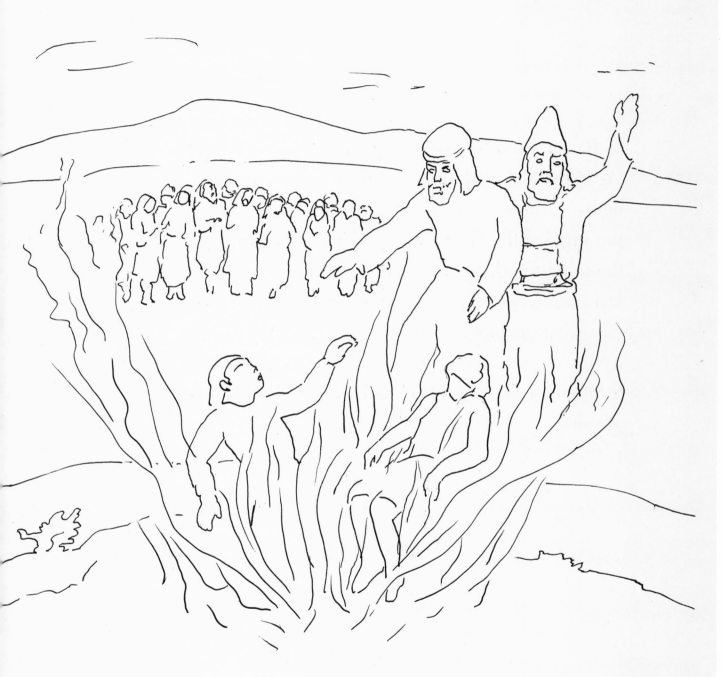

Then the Lord opened the eyes of Balaam, and he saw the angel of the Lord standing in the way, and his sword drawn in his hand: and he bowed down his head, and fell flat on his face. And the angel of the Lord said unto him, Wherefore hast thou smitten thine ass these three times? behold, I went out to withstand thee, because thy way is perverse before me: and the ass saw me, and turned from me these three times: unless she had turned from me, surely now also I had slain thee, and saved her alive.

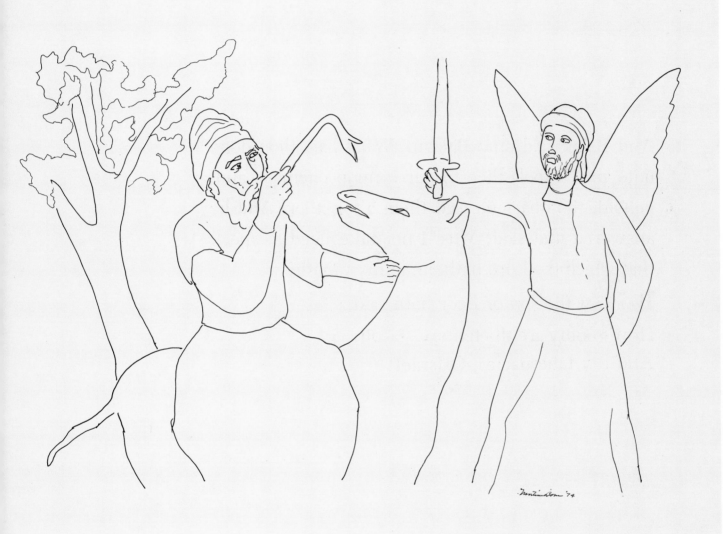

And Balak said unto Balaam, What hast thou done
unto me? I took thee to curse mine enemies, and,
behold, thou hast blessed them altogether. And he
answered and said, Must I not take heed to speak
that which the Lord hath put in my mouth?

BALAAM the son of Beor hath said,
How goodly are thy tents, O Jacob,
And thy tabernacles, O Israel!

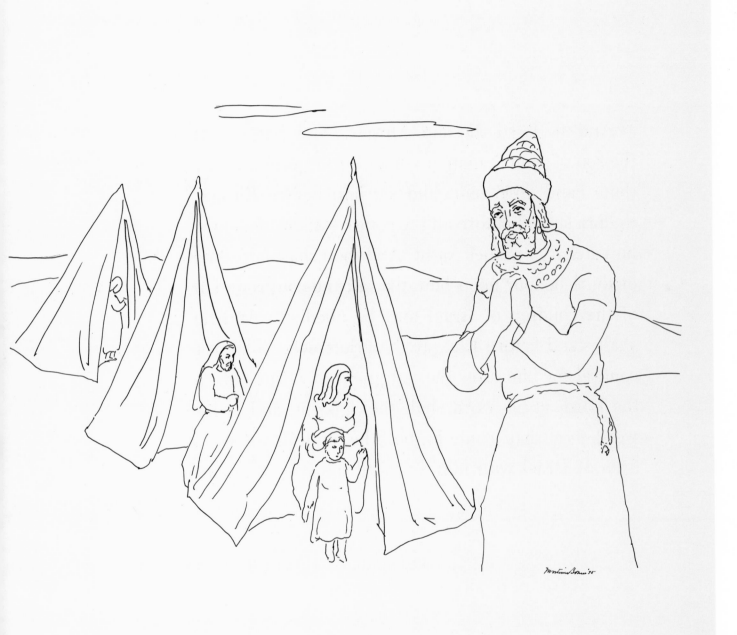

And the Lord said unto Moses, Take thee Joshua the son of Nun, a man in whom is the spirit, and lay thine hand upon him; and set him before Eleazar the priest, and before all the congregation; and give him a charge in their sight. And thou shalt put some of thine honour upon him, that all the congregation of the children of Israel may be obedient. And he shall stand before Eleazar the priest, who shall ask counsel for him after the judgment of Urim before the Lord: at his word shall they go out, and at his word they shall come in, both he, and all the children of Israel with him, even all the congregation.

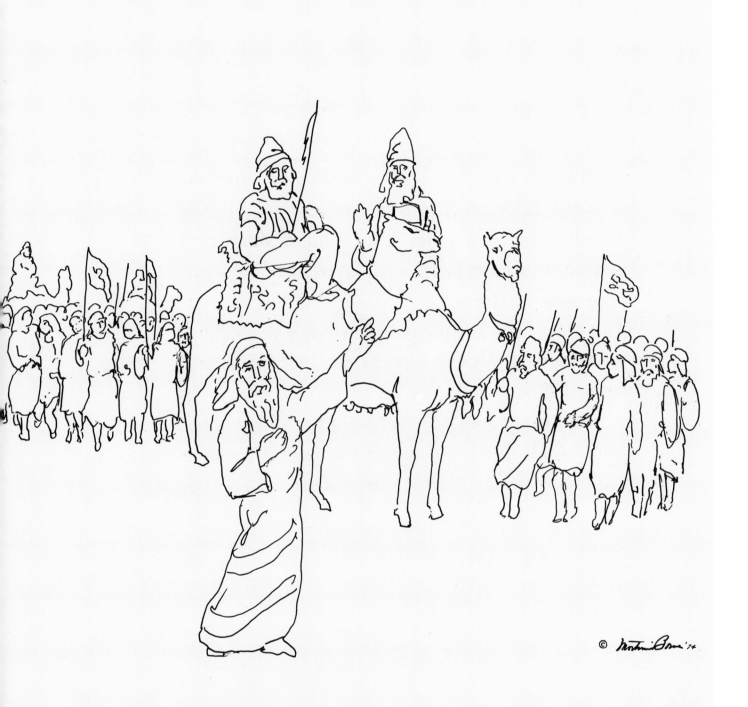

So Moses the servant of the Lord died there in the land of Moab, according to the word of the Lord. And he buried him in a valley in the land of Moab, over against Beth-peor: but no man knoweth of his sepulchre unto this day.

And Moses was an hundred and twenty years old when he died: his eye was not dim, nor his natural force abated.

And the children of Israel wept for Moses in the plains of Moab thirty days: so the days of weeping and mourning for Moses were ended.

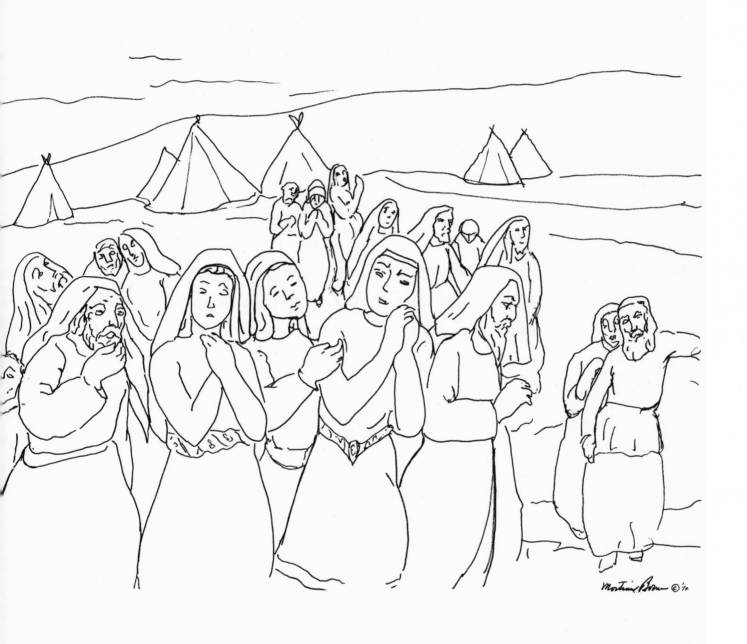

AND Joshua the son of Nun sent out of Shittim two men to spy secretly, saying, Go view the land, even Jericho. And they went, and came into an harlot's house, named Rahab, and lodged there. And it was told the king of Jericho, saying, Behold, there came men in hither to night of the children of Israel to search out the country. And the king of Jericho sent unto Rahab, saying, Bring forth the men that are come to thee, which are entered into thine house: for they be come to search out all the country. And the woman took the two men, and hid them, and said thus, There came men unto me, but I wist not whence they were: and it came to pass about the time of shutting of the gate, when it was dark, that the men went out: whither the men went I wot not: pursue after them quickly; for ye shall overtake them. But she had brought them up to the roof of the house, and hid them with the stalks of flax, which she had laid in order upon the roof.          Then she let them down by a cord through the window: for her house was upon the town wall, and she dwelt upon the wall.

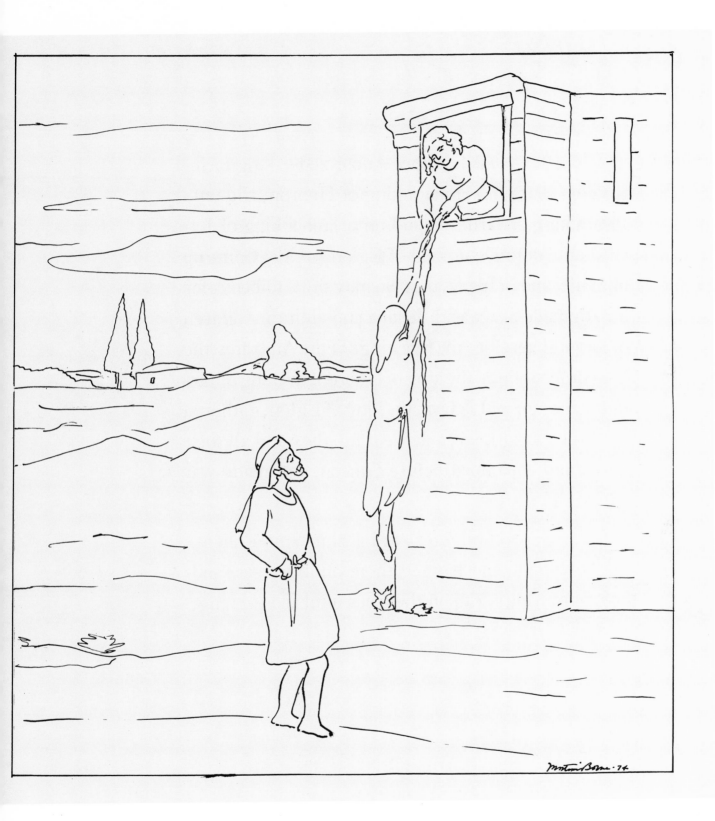

Wherefore Adoni-zedec king of Jerusalem sent unto Hoham king of Hebron, and unto Piram king of Jarmuth, and unto Japhia king of Lachish, and unto Debir king of Eglon, saying, Come up unto me, and help me, that we may smite Gibeon: for it hath made peace with Joshua and with the children of Israel. Therefore the five kings of the Amorites, the king of Jerusalem, the king of Hebron, the king of Jarmuth, the king of Lachish, the king of Eglon, gathered themselves together, and went up, they and all their hosts, **and encamped** before Gibeon, and made war against it.

And afterward Joshua smote them, and slew them, and hanged them on five trees: and they were hanging upon the trees until the evening.

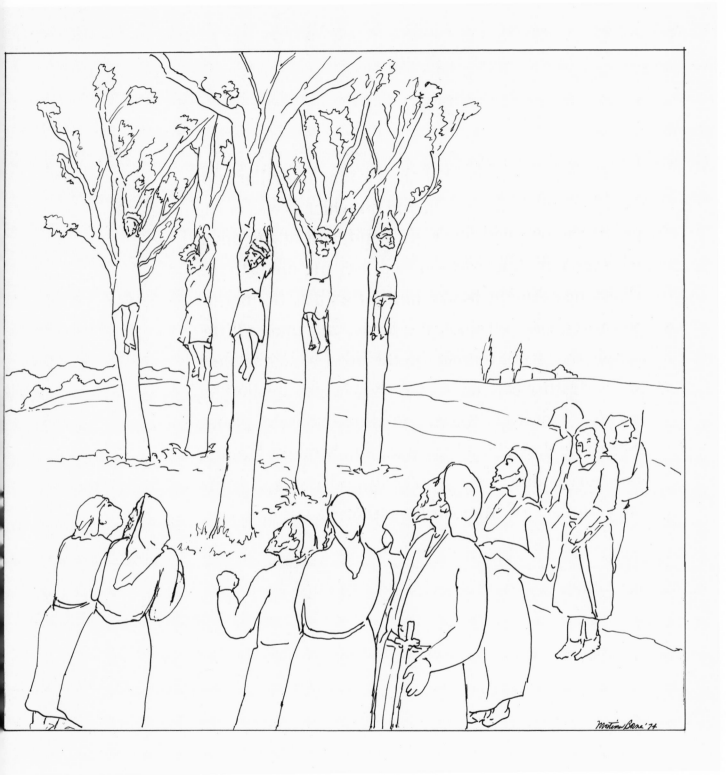

And Samson took hold of the two middle pillars up-on which the house stood, and on which it was borne up, of the one with his right hand, and of the other with his left. And Samson said, Let me die with the Philistines. And he bowed himself with all his might; and the house fell upon the lords, and upon all the people that were therein. So the dead which he slew at his death were more than they which he slew in his life. Then his brethren and all the house of his father came down, and took him, and brought him up, and buried him between Zorah and Eshtaol in the buryingplace of Manoah his father.

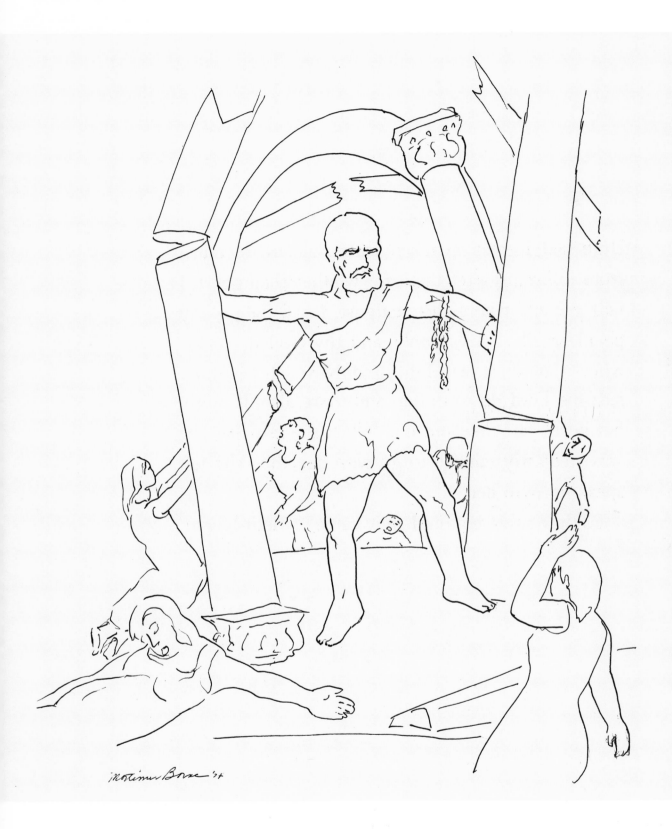

Ruth said, Intreat me not to leave thee, or to return from following after thee: for whither thou goest, I will go; and where thou lodgest, I will lodge: thy people shall be my people, and thy God my God: where thou diest, will I die, and there will I be buried: the Lord do so to me, and more also, if ought but death part thee and me. When she saw that she was stedfastly minded to go with her, then she left speaking unto her.

So they two went until they came to Beth-lehem.

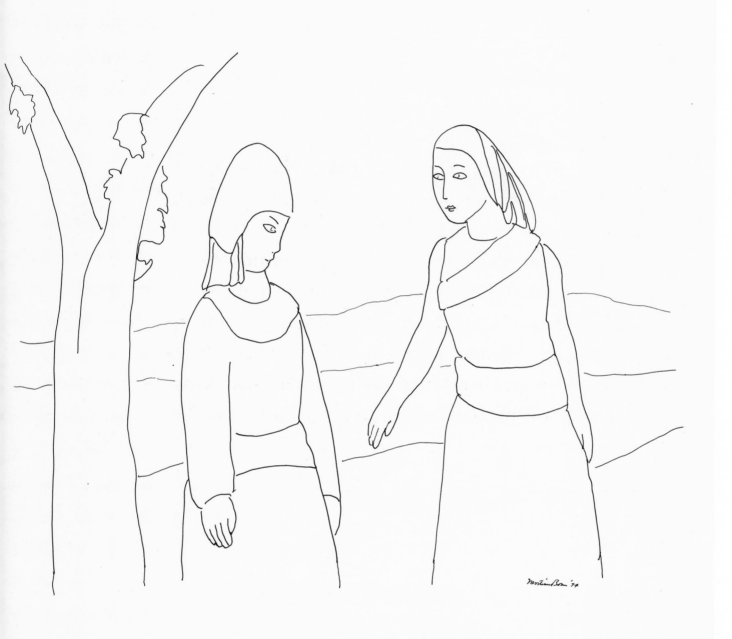

AND it came to pass, when Samuel was old, that he made his sons judges over Israel. Now the name of his firstborn was Joel; and the name of his second, Abiah: they were judges in Beer-sheba. And his sons walked not in his ways, but turned aside after lucre, and took bribes, and perverted judgment. Then all the elders of Israel gathered themselves together, and came to Samuel unto Ramah, and said unto him, Behold, thou art old, and thy sons walk not in thy ways: now make us a king to judge us like all the nations.

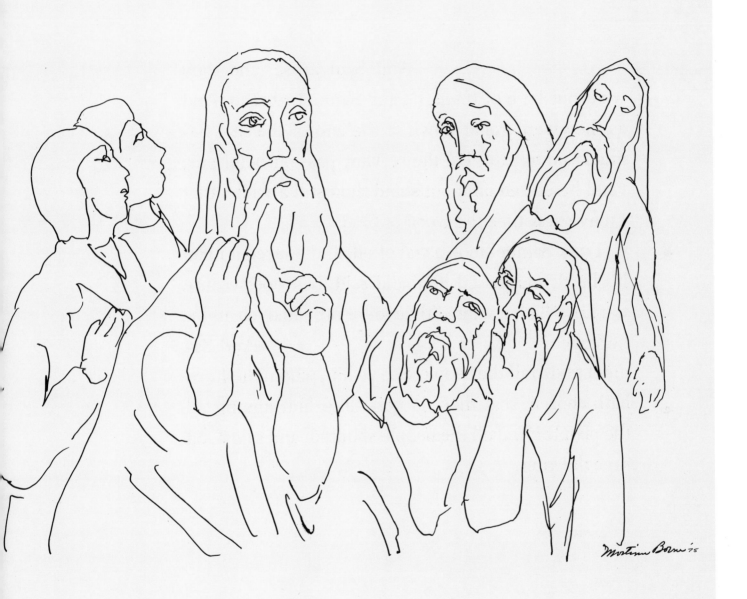

And Saul arose, and they went out both of them, he and Samuel, abroad. And as they were going down to the end of the city, Samuel said to Saul, Bid the servant pass on before us, (and he passed on,) but stand thou still a while, that I may shew thee the word of God.

THEN Samuel took a vial of oil, and poured it upon his head, and kissed him, and said, Is it not because the Lord hath anointed thee to be captain over his inheritance?                    And Samuel said to all the people, See ye him whom the Lord hath chosen, that there is none like him among all the people? And all the people shouted, and said, God save the king.

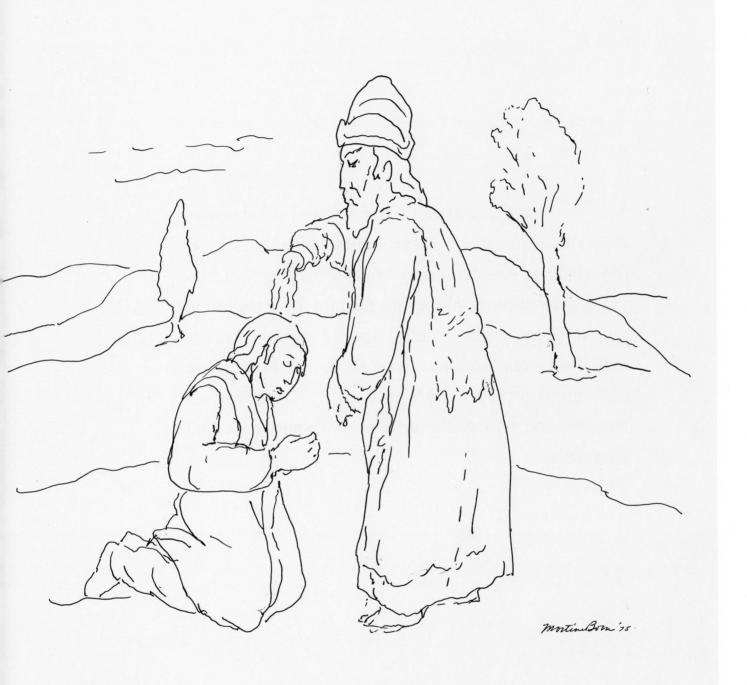

And David came to Saul, and stood before him: and he loved him greatly; and he became his armourbearer. And Saul sent to Jesse, saying, Let David, I pray thee, stand before me; for he hath found favour in my sight. And it came to pass, when the evil spirit from God was upon Saul, that David took an harp, and played with his hand: so Saul was refreshed, and was well, and the evil spirit departed from him.

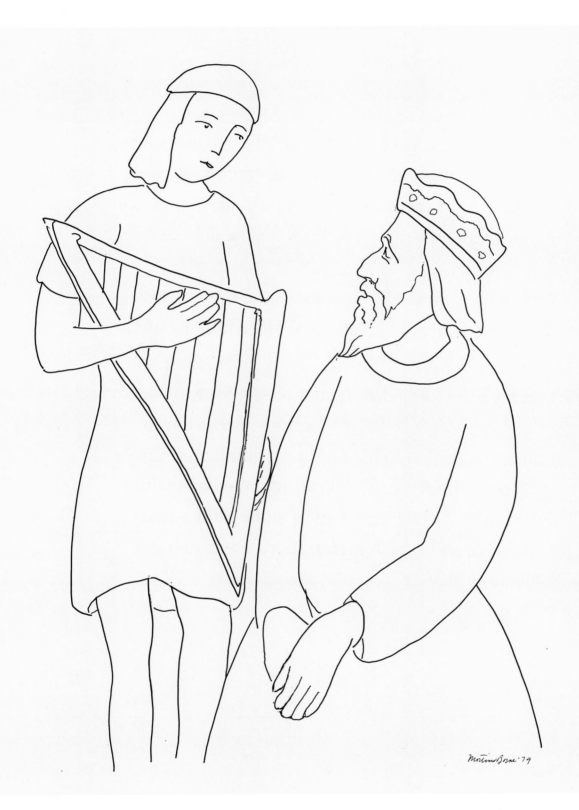

And he took his staff in his hand, and chose him five smooth stones out of the brook, and put them in a shepherd's bag which he had, even in a scrip; and his sling was in his hand: and he drew near to the Philistine.

And there went out a champion out of the camp of the Philistines, named Goliath, of Gath, whose height was six cubits and a span. And David put his hand in his bag, and took thence a stone, and slang it, and smote the Philistine in his forehead, that the stone sunk into his forehead; and he fell upon his face to the earth. So David prevailed over the Philistine with a sling and with a stone, and smote the Philistine, and slew him; but there was no sword in the hand of David.

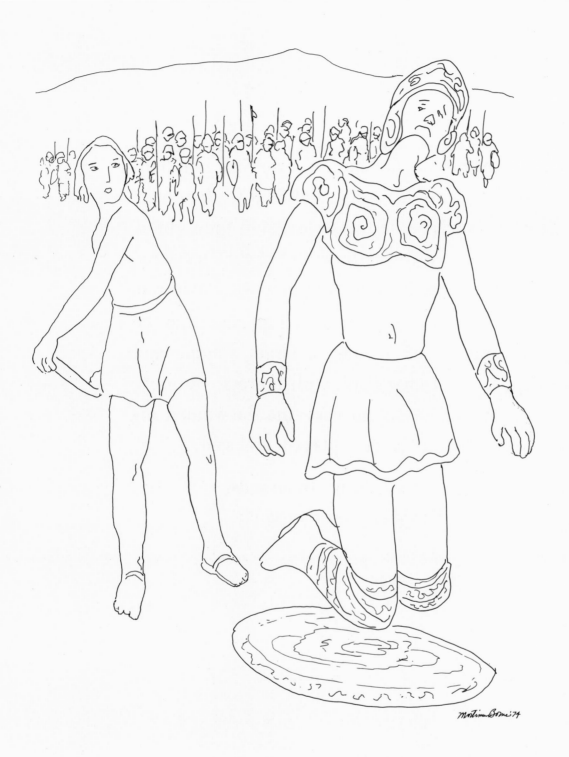

And David went out whithersoever Saul sent him, and behaved himself wisely: and Saul set him over the men of war, and he was accepted in the sight of all the people, and also in the sight of Saul's servants. And it came to pass as they came, when David was returned from the slaughter of the Philistine, that the women came out of all cities of Israel, singing and dancing, to meet king Saul, with tabrets, with joy, and with instruments of musick. And the women answered one another as they played, and said,

SAUL hath slain his thousands,
And David his ten thousands.

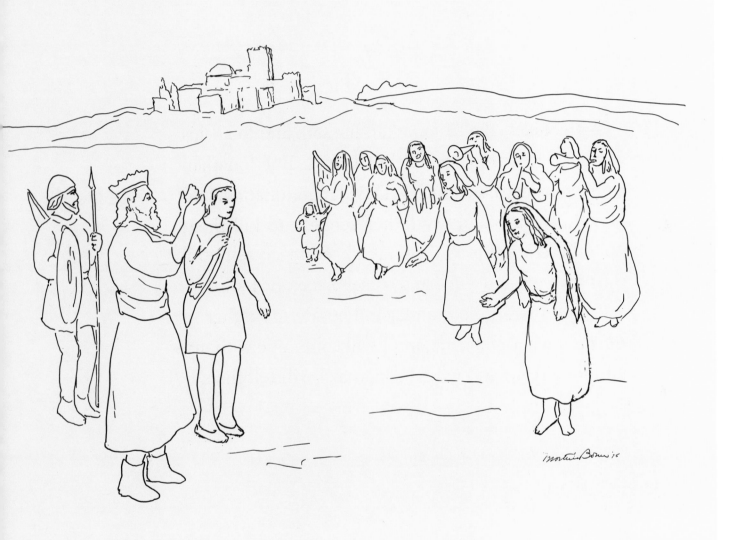

AND Saul spake to Jonathan his son, and to all his servants, that they should kill David. But Jonathan Saul's son delighted much in David: and Jonathan told David, saying, Saul my father seeketh to kill thee; now therefore, I pray thee, take heed to thyself until the morning, and abide in a secret place, and hide thyself: and I will go out and stand beside my father in the field where thou art, and I will commune with my father of thee; and what I see, that I will tell thee.

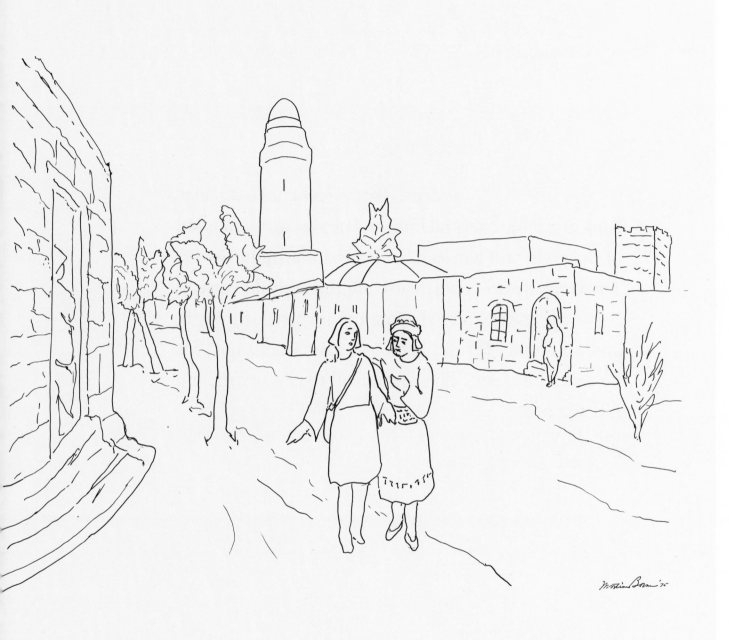

And the battle went sore against Saul, and the archers hit him; and he was sore wounded of the archers. Then said Saul unto his armourbearer, Draw thy sword, and thrust me through therewith; lest these uncircumcised come and thrust me through, and abuse me. But his armourbearer would not; for he was sore afraid. Therefore Saul took a sword, and fell upon it.

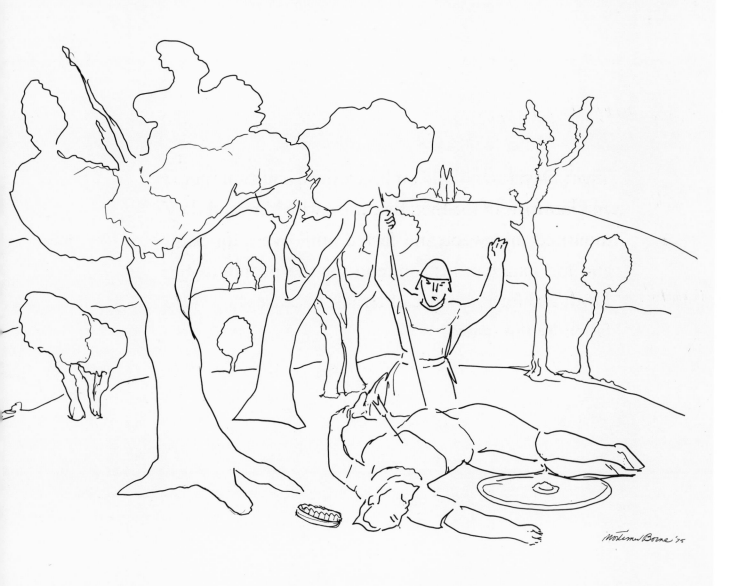

Then David took hold on his clothes, and rent them; and likewise all the men that were with him: and they mourned, and wept, and fasted until even, for Saul, and for Jonathan his son, and for the people of the Lord, and for the house of Israel; because they were fallen by the sword.

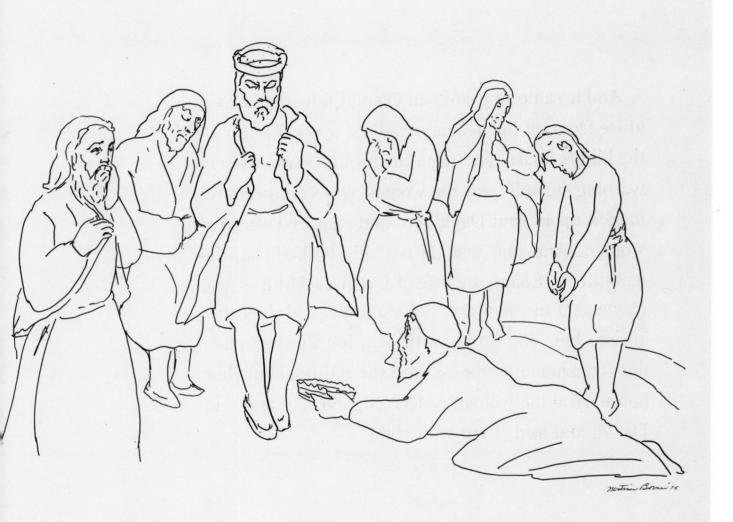

And it came to pass in an eveningtide, that David arose from off his bed, and walked upon the roof of the king's house: and from the roof he saw a woman washing herself; and the woman was very beautiful to look upon. And David sent and enquired after the woman. And one said, Is not this Bath-sheba, the daughter of Eliam, the wife of Uriah the Hittite? And David sent messengers, and took her; and she came in unto him, and he lay with her; for she was purified from her uncleanness: and she returned unto her house. And the woman conceived, and sent and told David, and said, I am with child.

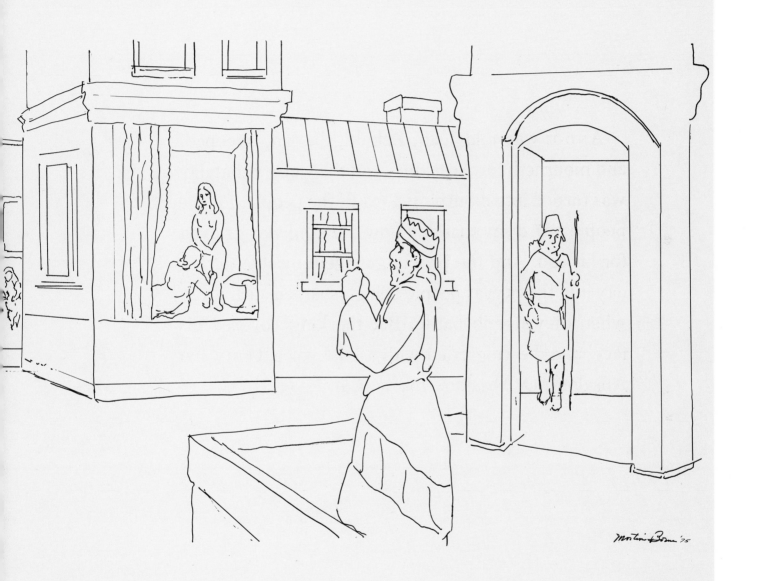

AND it was told Joab, Behold, the king weepeth and mourneth for Absalom. And the victory that day was turned into mourning unto all the people: for the people heard say that day how the king was grieved for his son. And the people gat them by stealth that day into the city, as people being ashamed steal away when they flee in battle. But the king covered his face, and the king cried with a loud voice, O my son Absalom, O Absalom, my son, my son!

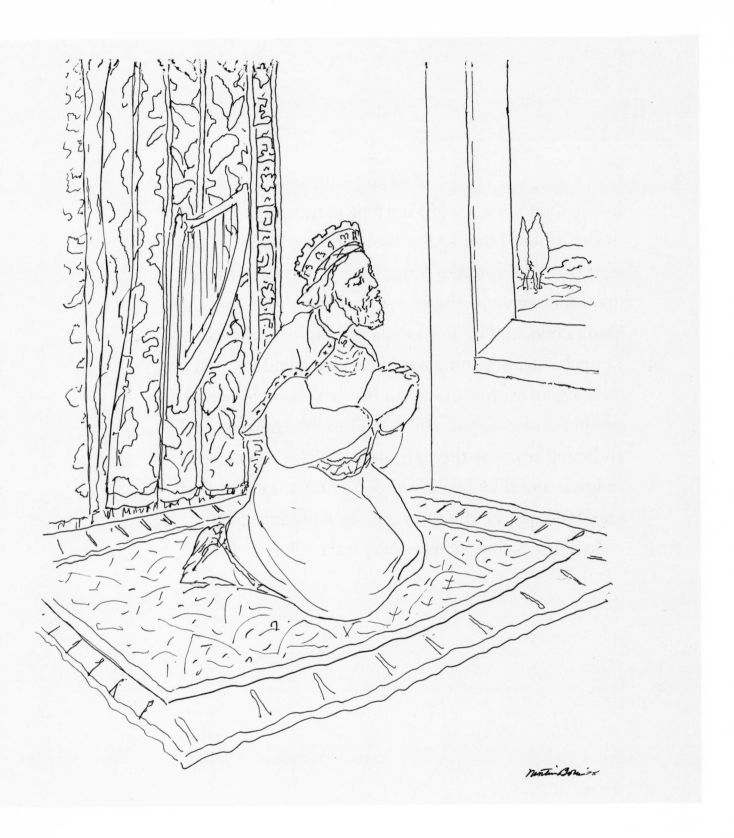

And the king said, Divide the living child in two, and give half to the one, and half to the other. Then spake the woman whose the living child was unto the king, for her bowels yearned upon her son, and she said, O my lord, give her the living child, and in no wise slay it. But the other said, Let it be neither mine nor thine, but divide it. Then the king answered and said, Give her the living child, and in no wise slay it: she is the mother thereof. And all Israel heard of the judgment which the king had judged; and they feared the king: for they saw that the wisdom of God was in him, to do judgment.

So king Solomon was king over all Israel.

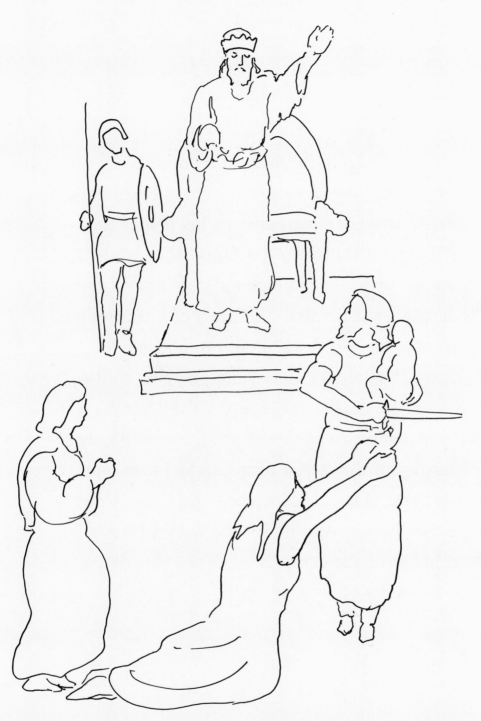

Then Jeroboam built Shechem in mount Ephraim, and dwelt therein; and went out from thence, and built Penuel. And Jeroboam said in his heart, Now shall the kingdom return to the house of David: if this people go up to do sacrifice in the house of the Lord at Jerusalem, then shall the heart of this people turn again unto their lord, even unto Rehoboam king of Judah, and they shall kill me, and go again to Rehoboam king of Judah. Whereupon the king took counsel, and made two calves of gold, and said unto them, It is too much for you to go up to Jerusalem: behold thy gods, O Israel, which brought thee up out of the land of Egypt. And he set the one in Beth-el, and the other put he in Dan.

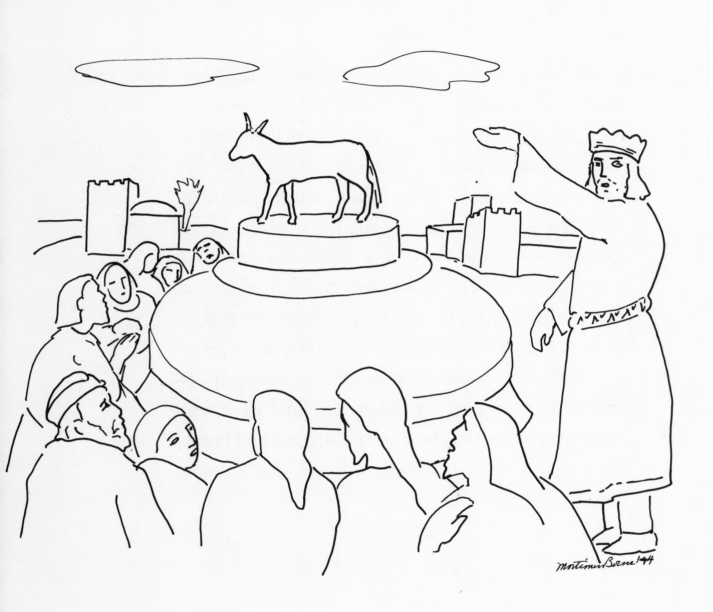

And there was war between Asa and Baasha king of Israel all their days. And Baasha king of Israel went up against Judah, and built Ramah, that he might not suffer any to go out or come in to Asa king of Judah. Then Asa took all the silver and the gold that were left in the treasures of the house of the Lord, and the treasures of the king's house, and delivered them into the hand of his servants: and king Asa sent them to Ben-hadad, the son of Tabrimon, the son of Hezion, king of Syria, that dwelt at Damascus, saying, There is a league between me and thee, and between my father and thy father: behold, I have sent unto thee a present of silver and gold; come and break thy league with Baasha king of Israel, that he may depart from me.

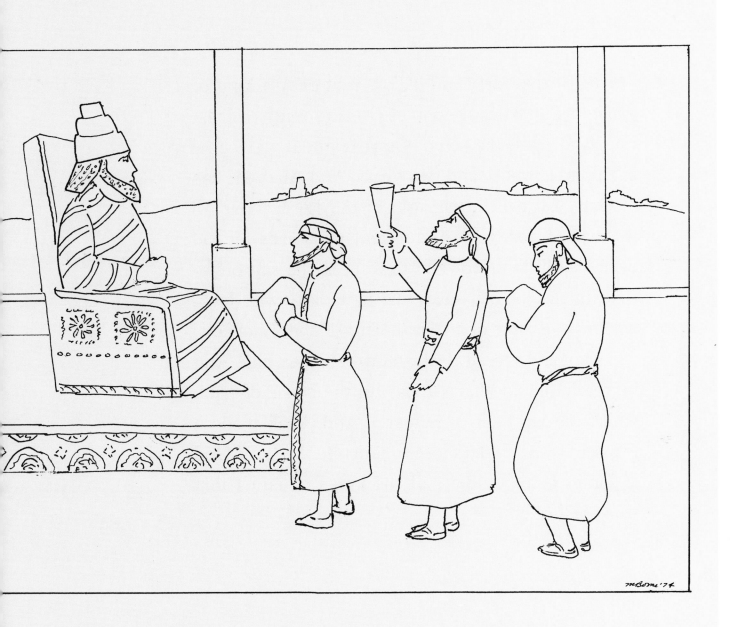

And in the thirty and eighth year of Asa king of Judah began Ahab the son of Omri to reign over Israel: and Ahab the son of Omri reigned over Israel in Samaria twenty and two years. And Ahab the son of Omri did evil in the sight of the Lord above all that were before him. And it came to pass, as if it had been a light thing for him to walk in the sins of Jeroboam the son of Nebat, that he took to wife Jezebel the daughter of Ethbaal king of the Zidonians, and went and served Baal, and worshipped him. And he reared up an altar for Baal in the house of Baal, which he had built in Samaria. And Ahab made a grove; and Ahab did more to provoke the Lord God of Israel to anger than all the kings of Israel that were before him.

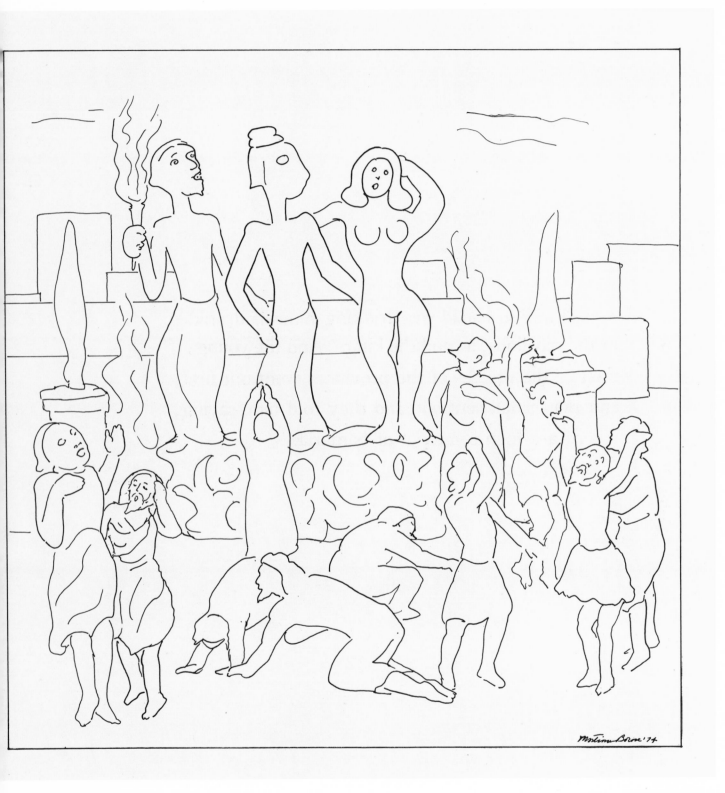

But Ben-hadad was drinking himself drunk
in the pavilions, he and the kings. And the young
men of the princes of the provinces went out first;
and Ben-hadad sent out, and they told him, saying,
There are men come out of Samaria.

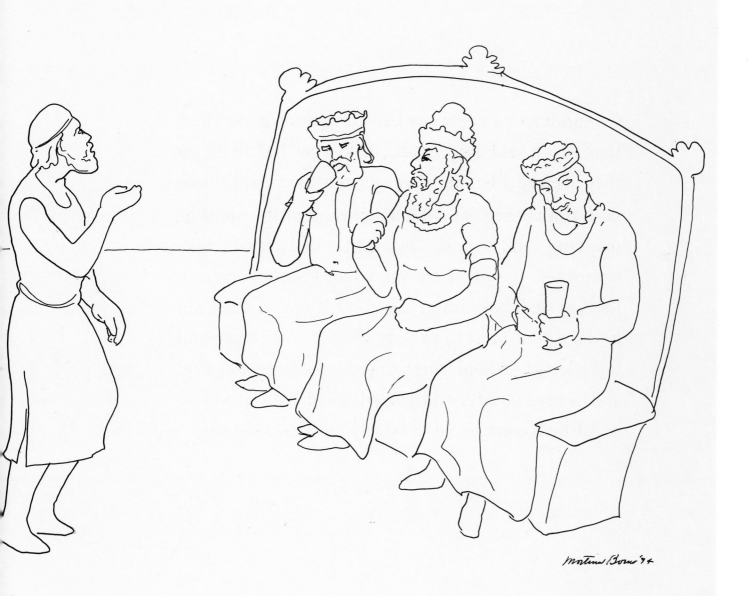

And it came to pass, when they were gone over,
that Elijah said unto Elisha, Ask what I shall do for
thee, before I be taken away from thee. And Elisha
said, I pray thee, let a double portion of thy spirit be
upon me. And he said, Thou hast asked a hard thing:
nevertheless, if thou see me when I am taken from
thee, it shall be so unto thee; but if not, it shall not
be so. And it came to pass, as they still went on, and
talked, that, behold, there appeared a chariot of fire,
and horses of fire, and parted them both asunder;
and Elijah went up by a whirlwind into heaven.

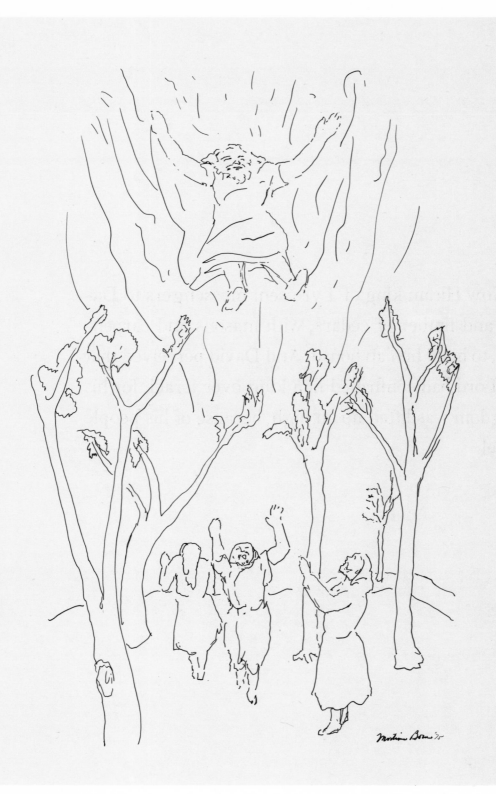

Now Hiram king of Tyre sent messengers to David, and timber of cedars, with masons and carpenters, to build him an house. And David perceived that the Lord had confirmed him king over Israel, for his kingdom was lifted up on high, because of his people Israel.

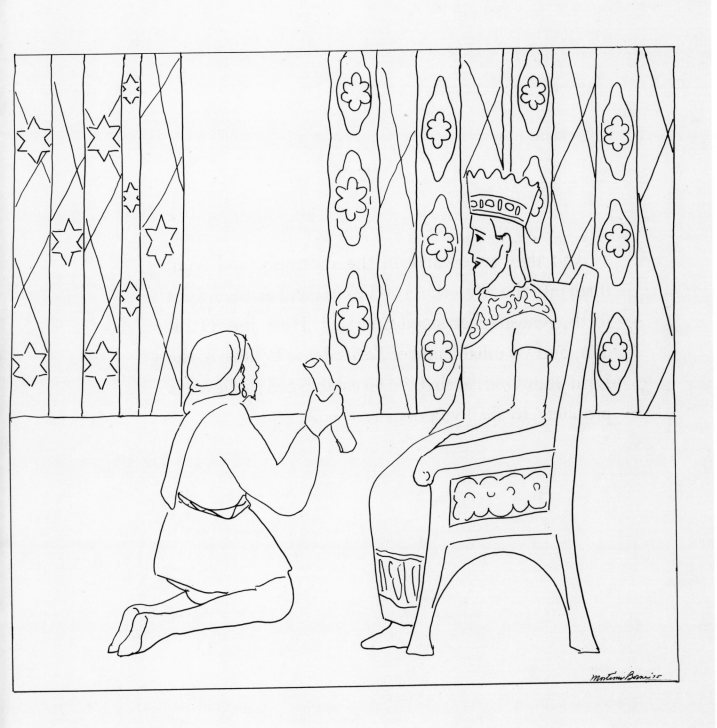

And they rose early in the morning, and went forth into the wilderness of Tekoa: and as they went forth, Jehoshaphat stood and said, Hear me, O Judah, and ye inhabitants of Jerusalem: Believe in the Lord your God, so shall ye be established; believe his prophets, so shall ye prosper.

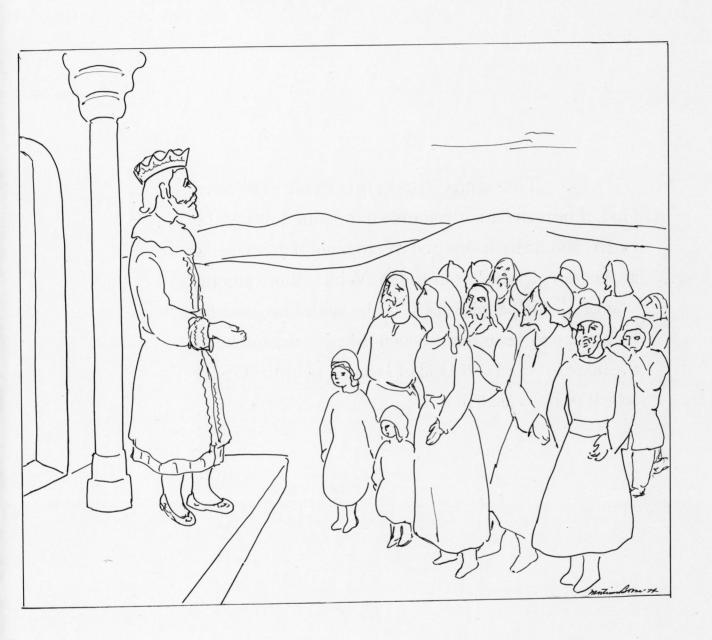

Thus saith Cyrus king of Persia, The Lord
God of heaven hath given me all the kingdoms of the
earth; and he hath charged me to build him an house
at Jerusalem, which is in Judah. Who is there among
you of all his people? his God be with him, and let
him go up to Jerusalem, which is in Judah, and build
the house of the Lord God of Israel, ( he is the God, )
which is in Jerusalem.

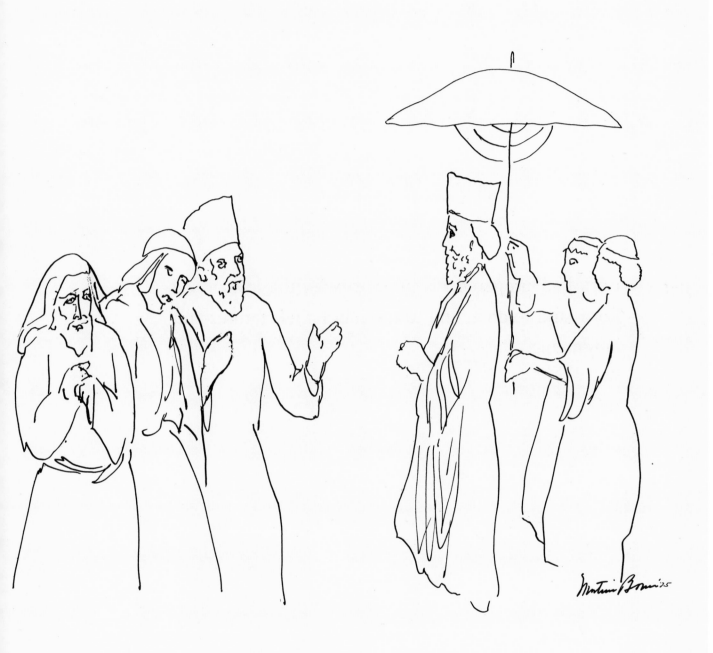

Ezra had prepared his heart to seek the law of the Lord, and to do it, and to teach in Israel statutes and judgments.

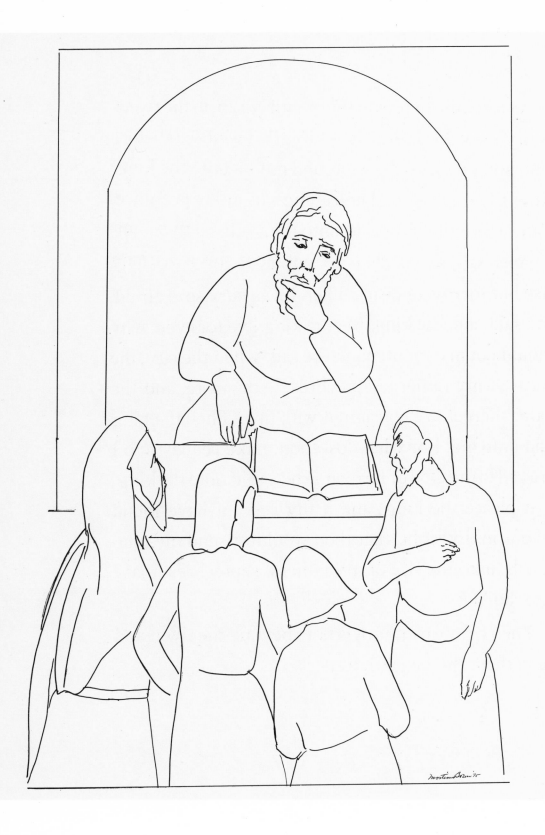

AND it came to pass in the month Nisan, in the twentieth year of Artaxerxes the king, that wine was before him: and I took up the wine, and gave it unto the king. Now I had not been beforetime sad in his presence. Wherefore the king said unto me, Why is thy countenance sad, seeing thou art not sick? this is nothing else but sorrow of heart. Then I was very sore afraid, and said unto the king, Let the king live for ever: why should not my countenance be sad, when the city, the place of my fathers' sepulchres, lieth waste, and the gates thereof are consumed with fire? Then the king said unto me, For what dost thou make request? So I prayed to the God of heaven. And I said unto the king, If it please the king, and if thy servant have found favour in thy sight, that thou wouldest send me unto Judah, unto the city of my fathers' sepulchres, that I may build it.

Then I came to the governors beyond the river, and gave them the king's letters.

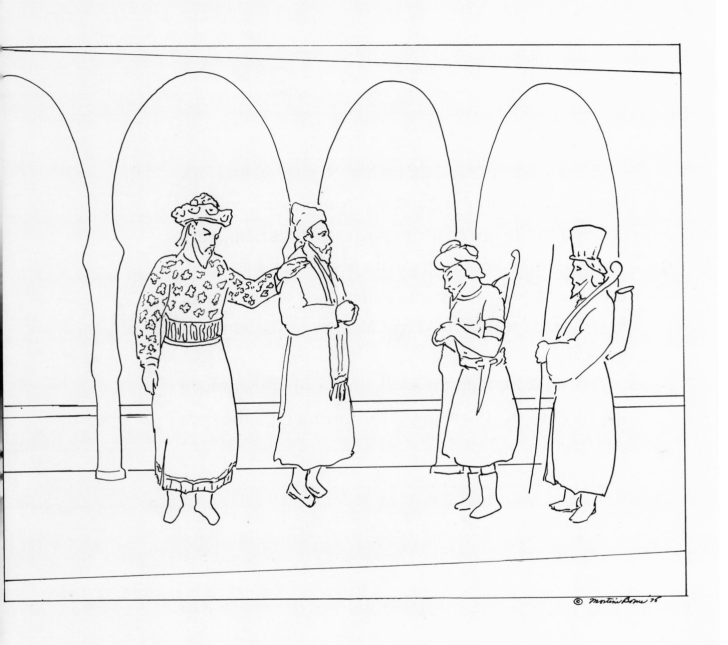

But it came to pass, that when Sanballat, and Tobiah, and the Arabians, and the Ammonites, and the Ashdodites, heard that the walls of Jerusalem were made up, and that the breaches began to be stopped, then they were very wroth, and conspired all of them together to come and to fight against Jerusalem, and to hinder it.

So we laboured in the work: and half of them held the spears from the rising of the morning till the stars appeared.

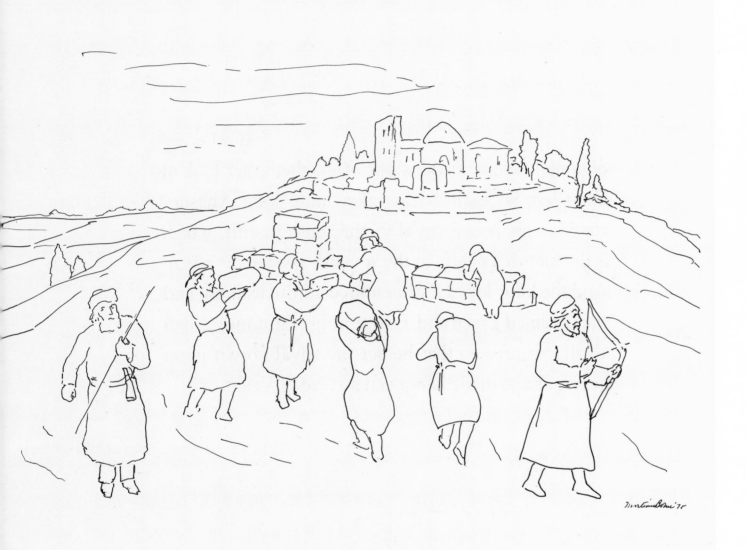

And Esther obtained favour in the sight of all them that looked upon her. So Esther was taken unto king Ahasuerus into his house royal in the tenth month, which is the month Tebeth, in the seventh year of his reign. And the king loved Esther above all the women, and she obtained grace and favour in his sight more than all the virgins; so that he set the royal crown upon her head, and made her queen instead of Vashti.

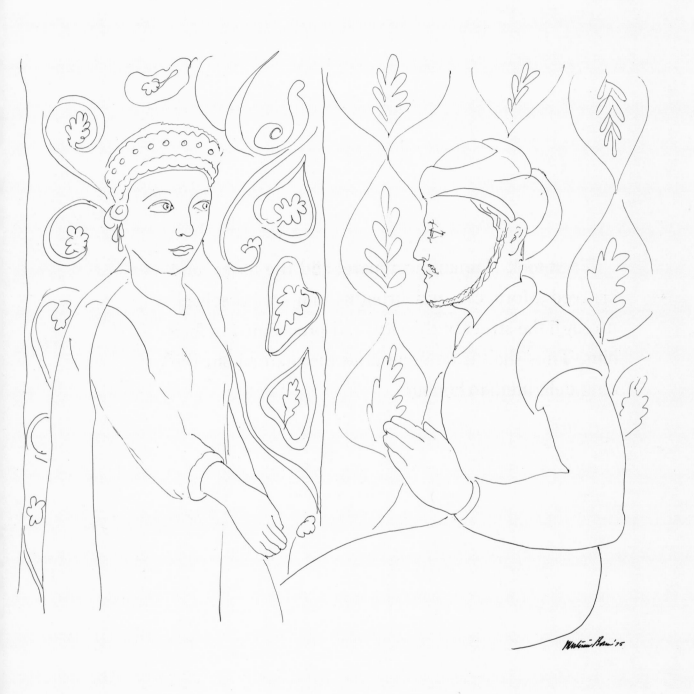

Then took Haman the apparel and the horse, and arrayed Mordecai, and brought him on horseback through the street of the city, and proclaimed before him, Thus shall it be done unto the man whom the king delighteth to honour.

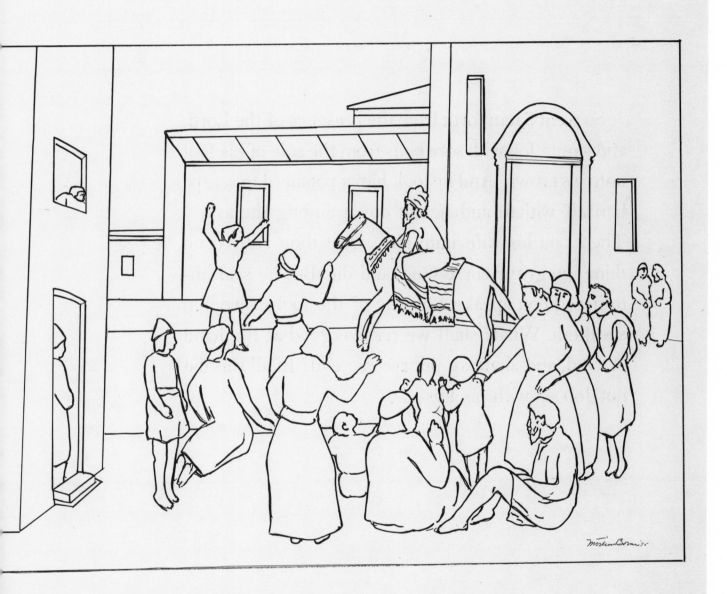

So went Satan forth from the presence of the Lord, and smote Job with sore boils from the sole of his foot unto his crown. And he took him a potsherd to scrape himself withal; and he sat down among the ashes. Then said his wife unto him, Dost thou still retain thine integrity? curse God, and die. But he said unto her, Thou speakest as one of the foolish women speaketh. What? shall we receive good at the hand of God, and shall we not receive evil? In all this did not Job sin with his lips.

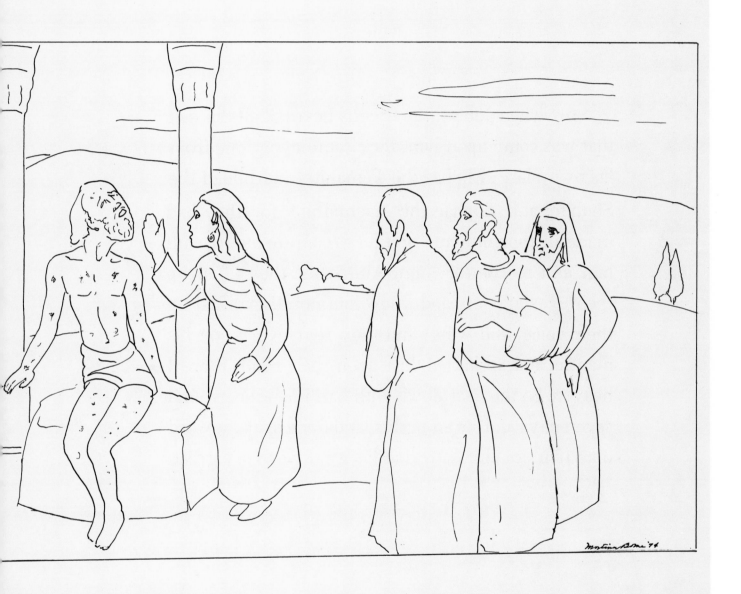

Now when Job's three friends heard of all this evil that was come upon him, they came every one from his own place; Eliphaz the Temanite, and Bildad the Shuhite, and Zophar the Naamathite: for they had made an appointment together to come to mourn with him and to comfort him. And when they lifted up their eyes afar off, and knew him not, they lifted up their voice, and wept; and they rent every one his mantle, and sprinkled dust upon their heads toward heaven. So they sat down with him upon the ground seven days and seven nights, and none spake a word unto him: for they saw that his grief was very great.

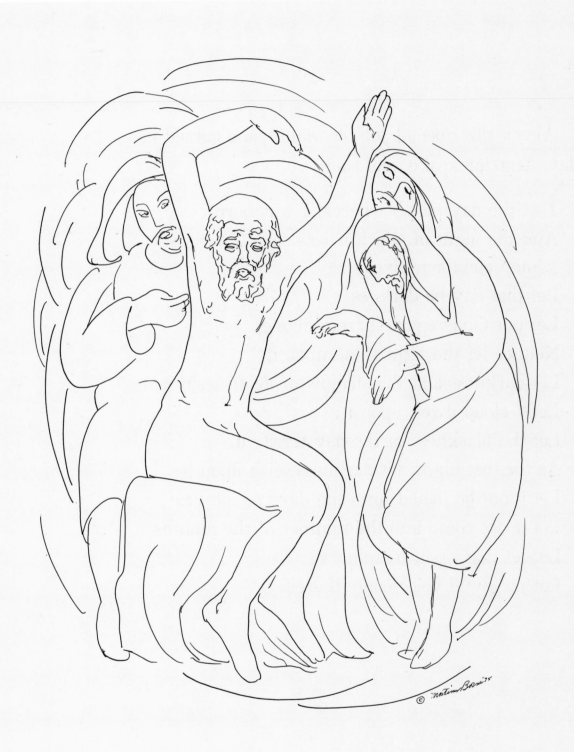

AFTER this opened Job his mouth, and cursed his
day. And Job spake, and said,

LET the day perish wherein I was born,
And the night in which it was said, There is a
    man child conceived.
Let that day be darkness;
Let not God regard it from above,
Neither let the light shine upon it.
Let darkness and the shadow of death stain it;
Let a cloud dwell upon it;
Let the blackness of the day terrify it.
As for that night, let darkness seize upon it;
Let it not be joined unto the days of the year,
Let it not come into the number of the months.
Lo, let that night be solitary,
Let no joyful voice come therein.

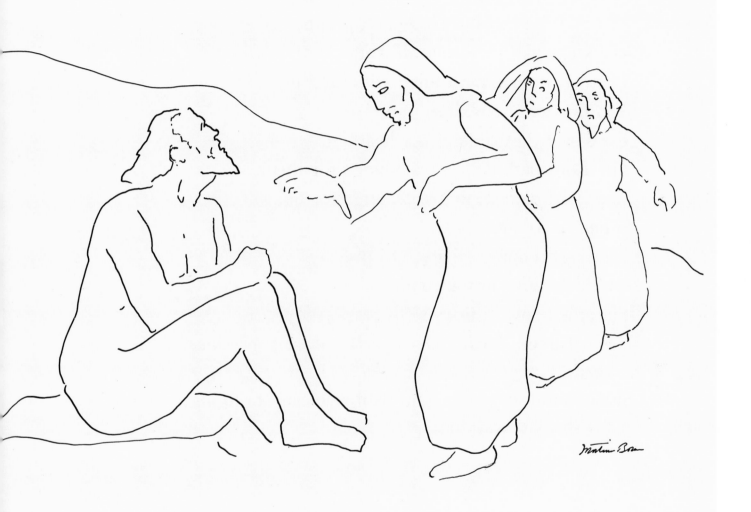

WHEN the Lord turned again the captivity of Zion,
We were like them that dream.
Then was our mouth filled with laughter,
And our tongue with singing:
Then said they among the heathen,
The Lord hath done great things for them.
The Lord hath done great things for us;
Whereof we are glad.
Turn again our captivity, O Lord,
As the streams in the south.
They that sow in tears shall reap in joy.
He that goeth forth and weepeth, bearing precious
    seed,
Shall doubtless come again with rejoicing, bringing
    his sheaves with him.

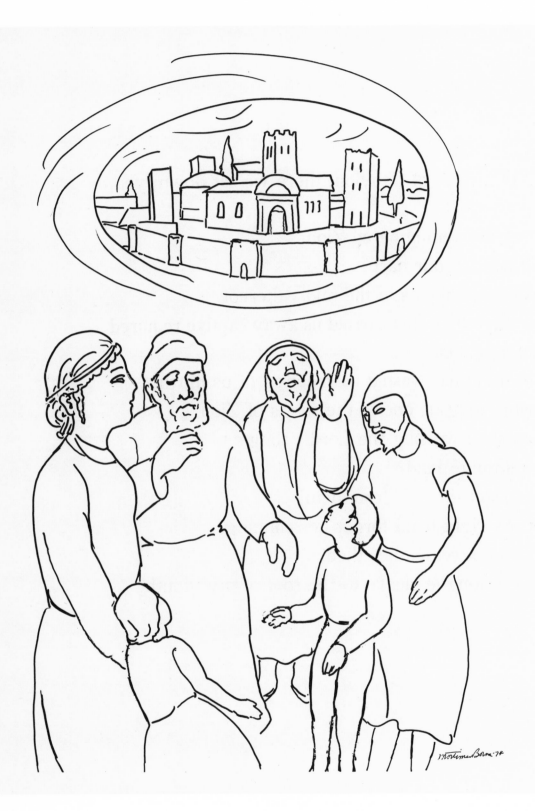

By the rivers of Babylon, there we sat down, yea,
    we wept,
When we remembered Zion.
We hanged our harps
Upon the willows in the midst thereof.
For there they that carried us away captive required
    of us a song;
And they that wasted us required of us mirth,
Saying, Sing us one of the songs of Zion.
How shall we sing the Lord's song
In a strange land?
If I forget thee, O Jerusalem,
Let my right hand forget her cunning.
If I do not remember thee,
Let my tongue cleave to the roof of my mouth.

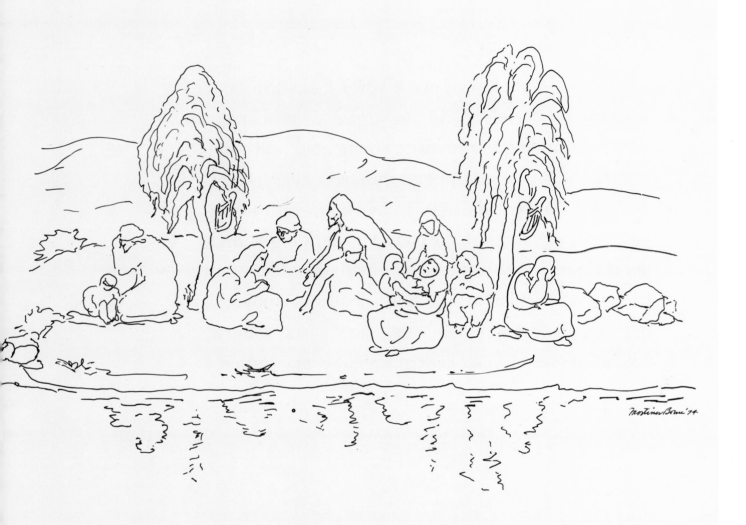

For at the window of my house I looked through my casement, and beheld among the simple ones, I discerned among the youths, a young man void of understanding, passing through the street near her corner; and he went the way to her house, in the twilight, in the evening, in the black and dark night: and, behold, there met him a woman with the attire of an harlot, and subtil of heart. (She is loud and stubborn; her feet abide not in her house: now is she without, now in the streets, and lieth in wait at every corner.)

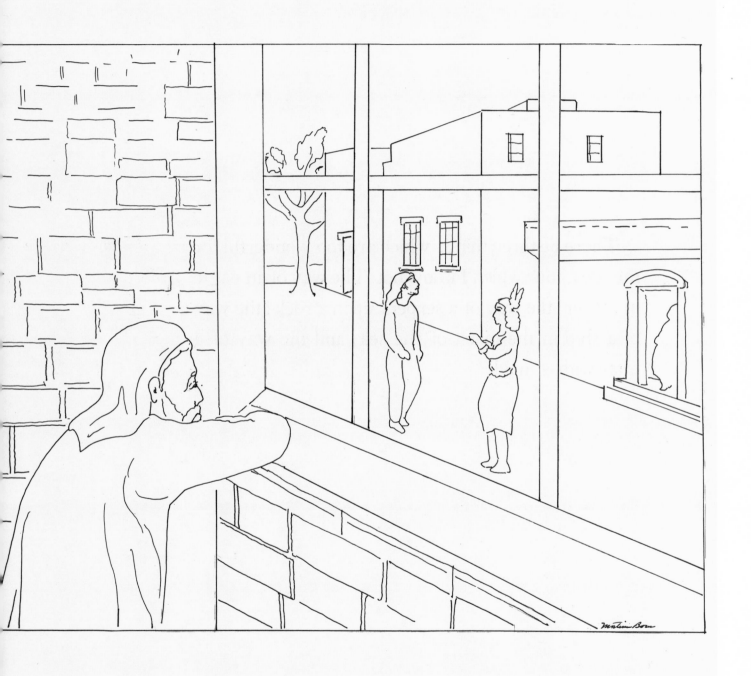

There be three things which are too wonderful for me, yea, four which I know not: The way of an eagle in the air; the way of a serpent upon a rock; the way of a ship in the midst of the sea; and the way of a man with a maid.

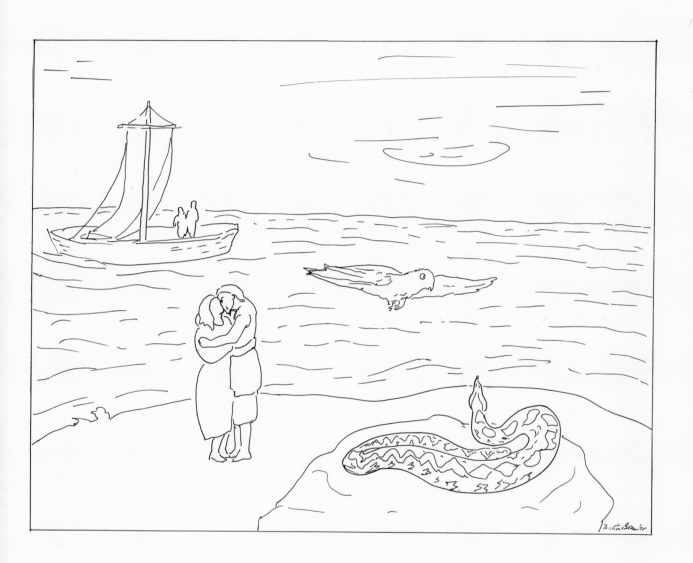

Vanity of vanities, saith the preacher; all is vanity.
And moreover, because the preacher was wise, he still taught the people knowledge; yea, he gave good heed, and sought out, and set in order many proverbs. The preacher sought to find out acceptable words: and that which was written was upright, even words of truth. The words of the wise are as goads, and as nails fastened by the masters of assemblies, which are given from one shepherd. And further, by these, my son, be admonished: of making many books there is no end; and much study is a weariness of the flesh.

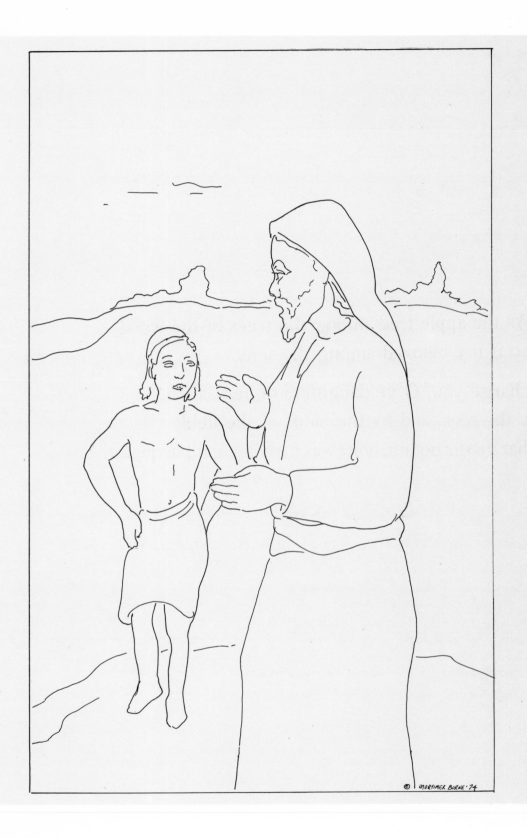

As the apple tree among the trees of the wood,
So is my beloved among the sons.

I charge you, O ye daughters of Jerusalem,
By the roes, and by the hinds of the field,
That ye stir not up, nor awake my love, till he please.

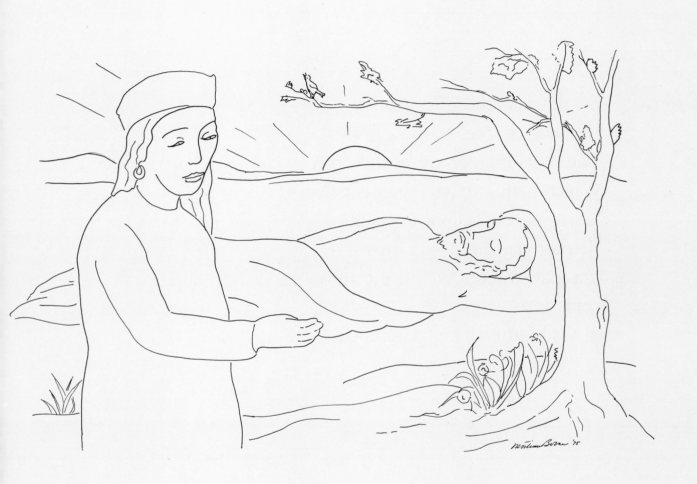

For love is strong as death;
Jealousy is cruel as the grave:
The coals thereof are coals of fire,
Which hath a most vehement flame.
Many waters cannot quench love,
Neither can the floods drown it:
If a man would give all the substance of his house
    for love,
It would utterly be contemned.

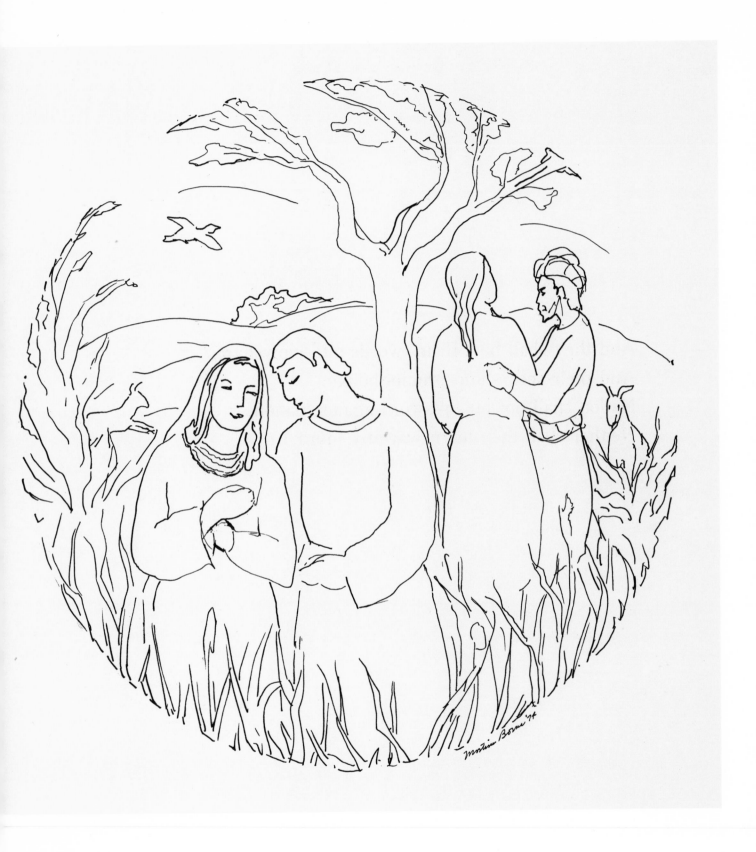

And **they** shall beat their swords into plowshares,
And **their** spears into pruninghooks:
**Nation** shall not lift up sword against nation,
**Neither** shall they learn war any more.

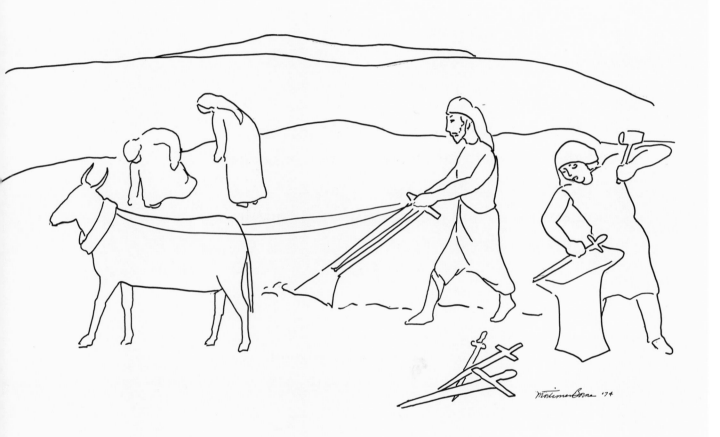

The wolf and the lamb shall feed together,
And the lion shall eat straw like the bullock:
And dust shall be the serpent's meat.
They shall not hurt nor destroy in all my holy
mountain, saith the Lord.

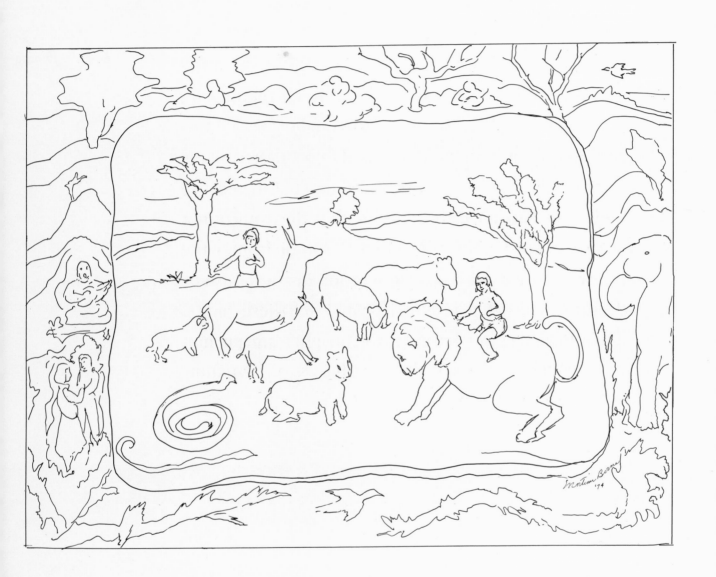

Then came Jeremiah from Tophet, whither the Lord had sent him to prophesy; and he stood in the court of the Lord's house; and said to all the people, Thus saith the Lord of hosts, the God of Israel; Behold, I will bring upon this city and upon all her towns all the evil that I have pronounced against it, because they have hardened their necks, that they might not hear my words. Now Pashur the son of Immer the priest, who was also chief governor in the house of the Lord, heard that Jeremiah prophesied these things. Then Pashur smote Jeremiah the prophet, and put him in the stocks that were in the high gate of Benjamin, which was by the house of the Lord.

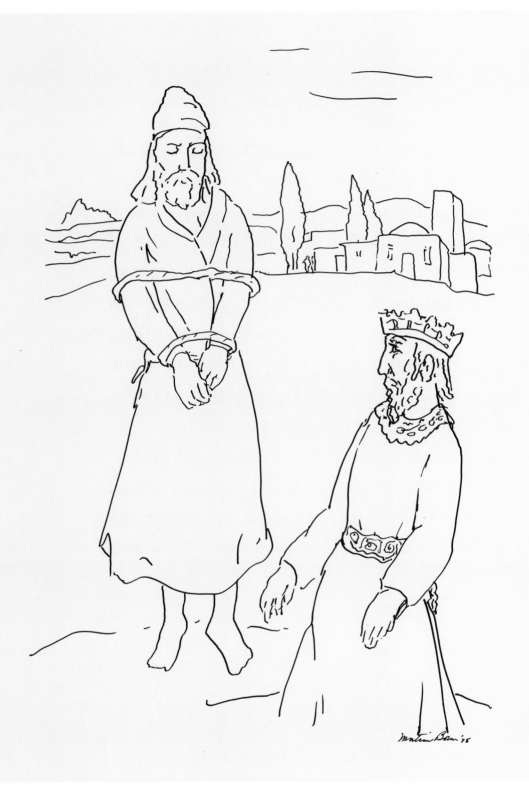

Then Jeremiah called Baruch the son of Neriah: and Baruch wrote from the mouth of Jeremiah all the words of the Lord, which he had spoken unto him, upon a roll of a book. And Jeremiah commanded Baruch, saying, I am shut up; I cannot go into the house of the Lord: therefore go thou, and read in the roll, which thou hast written from my mouth, the words of the Lord in the ears of the people in the Lord's house upon the fasting day: and also thou shalt read them in the ears of all Judah that come out of their cities. It may be they will present their supplication before the Lord, and will return every one from his evil way: for great is the anger and the fury that the Lord hath pronounced against this people.

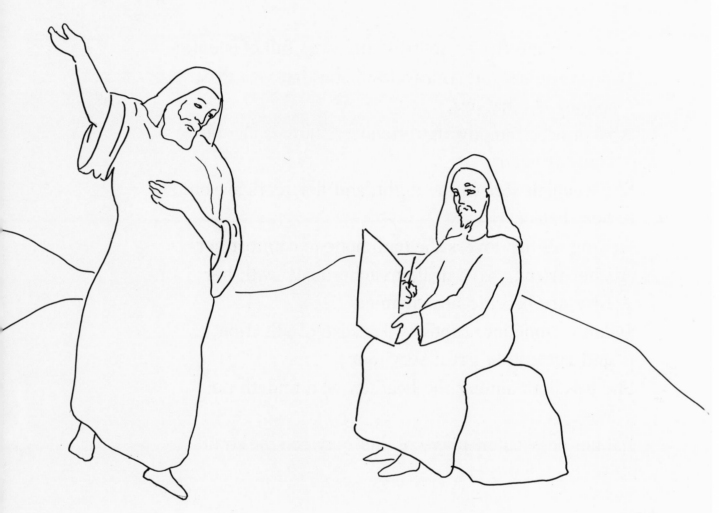

How doth the city sit solitary, that was full of people!

How is she become as a widow! she that was great
among the nations,

And princess among the provinces, how is she be-
come tributary!

She weepeth sore in the night, and her tears are on
her cheeks:

Among all her lovers she hath none to comfort her:

All her friends have dealt treacherously with her,
they are become her enemies.

Judah is gone into captivity because of affliction,
and because of great servitude:

She dwelleth among the heathen, she findeth no
rest:

All her persecutors overtook her between the straits.

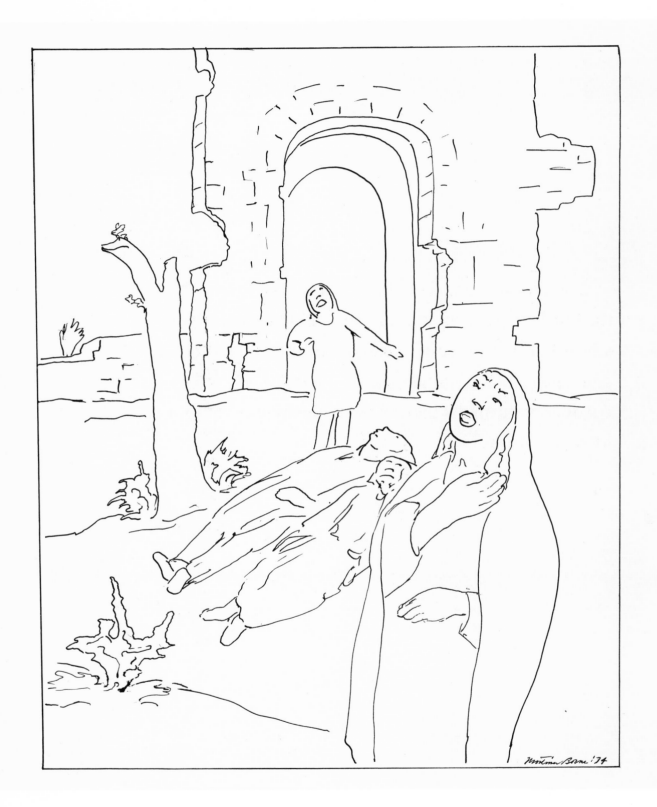

And I looked, and, behold, a whirlwind came out of the north, a great cloud, and a fire infolding itself, and a brightness was about it, and out of the midst thereof as the colour of amber, out of the midst of the fire. Also out of the midst thereof came the likeness of four living creatures.

And he said unto me, O Daniel, a man greatly beloved, understand the words that I speak unto thee, and stand upright: for unto thee am I now sent. And when he had spoken this word unto me, I stood trembling. Then said he unto me, Fear not, Daniel: for from the first day that thou didst set thine heart to understand, and to chasten thyself before thy God, thy words were heard, and I am come for thy words. But the prince of the kingdom of Persia withstood me one and twenty days: but, lo, Michael, one of the chief princes, came to help me.

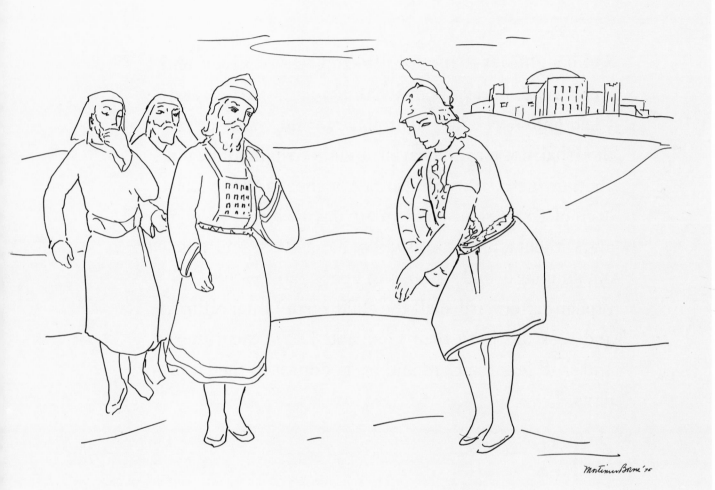

So I bought her to me for fifteen pieces of silver, and an homer of barley, and an half homer of barley: and I said unto her, Thou shalt abide for me many days; thou shalt not play the harlot, and thou shalt not be for another man: so will I also be for thee. For the children of Israel shall abide many days without a king, and without a prince, and without a sacrifice, and without an image, and without an ephod, and without teraphim: afterward shall the children of Israel return, and seek the Lord their God, and David their king; and shall fear the Lord and his goodness in the latter days.

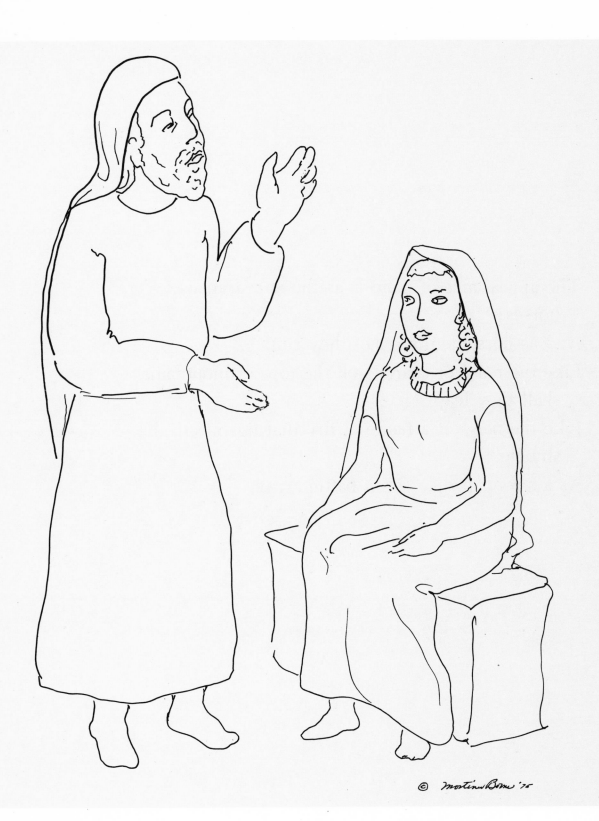

The appearance of them is as the appearance of
    horses;
And as horsemen, so shall they run.
Like the noise of chariots on the tops of mountains
    shall they leap,
Like the noise of a flame of fire that devoureth the
    stubble,
As a strong people set in battle array.

The words of Amos, who was among the
herd-men of Tekoa, which he saw concerning Israel
in the days of Uzziah king of Judah, and in the days
of Jeroboam the son of Joash king of Israel, two years
before the earthquake. And he said,

But I will send a fire into the house of Hazael,
Which shall devour the palaces of Ben-hadad.
I will break also the bar of Damascus,
And cut off the inhabitant from the plain of Aven,
And him that holdeth the sceptre from the house
    of Eden:
And the people of Syria shall go into captivity unto
    Kir, saith the Lord.

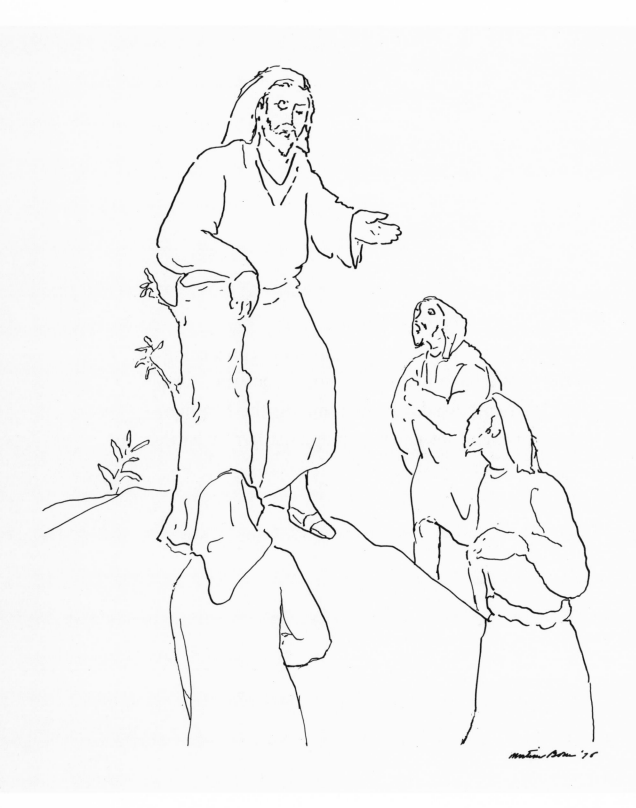

THE vision of Obadiah.

Thus saith the Lord God concerning
Edom; We have heard a rumour from the Lord,
And an ambassador is sent among the heathen,
Arise ye, and let us rise up against her in battle.

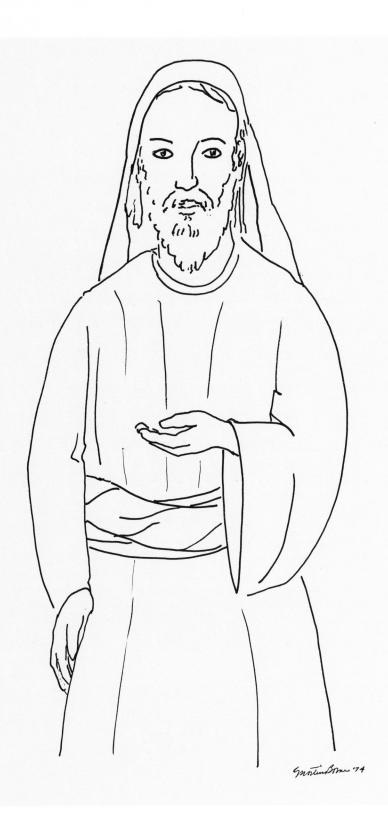

Now the word of the Lord came unto Jonah the son of Amittai, saying, Arise, go to Nineveh, that great city, and cry against it; for their wickedness is come up before me. But Jonah rose up to flee unto Tarshish from the presence of the Lord, and went down to Joppa; and he found a ship going to Tarshish: so he paid the fare thereof, and went down into it, to go with them unto Tarshish from the presence of the Lord.

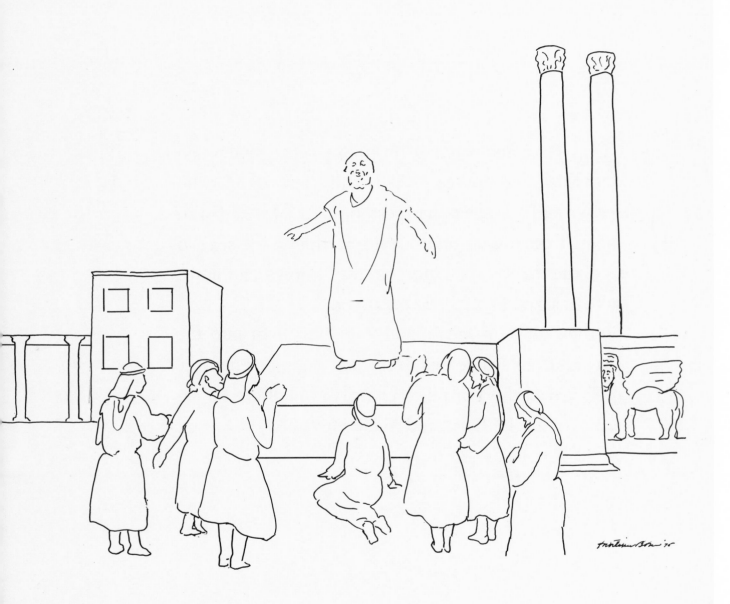

Then said they unto him, What shall we do unto thee, that the sea may be calm unto us? for the sea wrought, and was tempestuous. And he said unto them, Take me up, and cast me forth into the sea; so shall the sea be calm unto you: for I know that for my sake this great tempest is upon you.

So they took up Jonah, and cast him forth into the sea: and the sea ceased from her raging. Then the men feared the Lord exceedingly, and offered a sacrifice unto the Lord, and made vows.

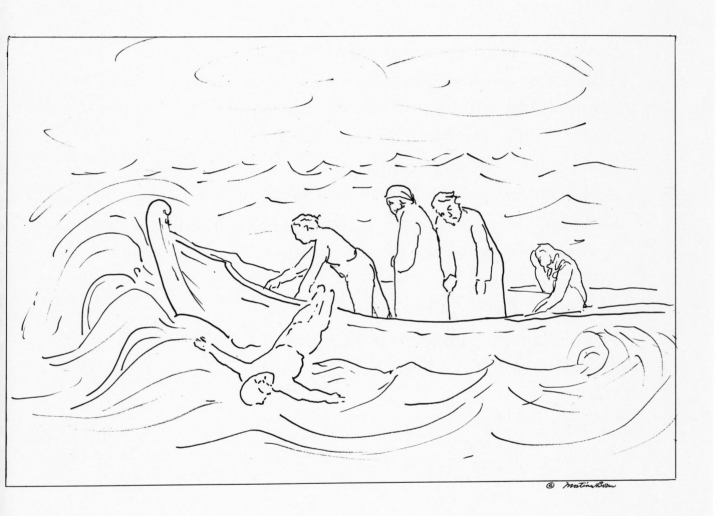

BUT in the last days it shall come to pass,
That the mountain of the house of the Lord shall be
    established in the top of the mountains,
And it shall be exalted above the hills;
And people shall flow unto it.
And many nations shall come, and say,
Come, and let us go up to the mountain of the Lord,
And to the house of the God of Jacob;
And he will teach us of his ways,
And we will walk in his paths:
For the law shall go forth of Zion,
And the word of the Lord from Jerusalem.

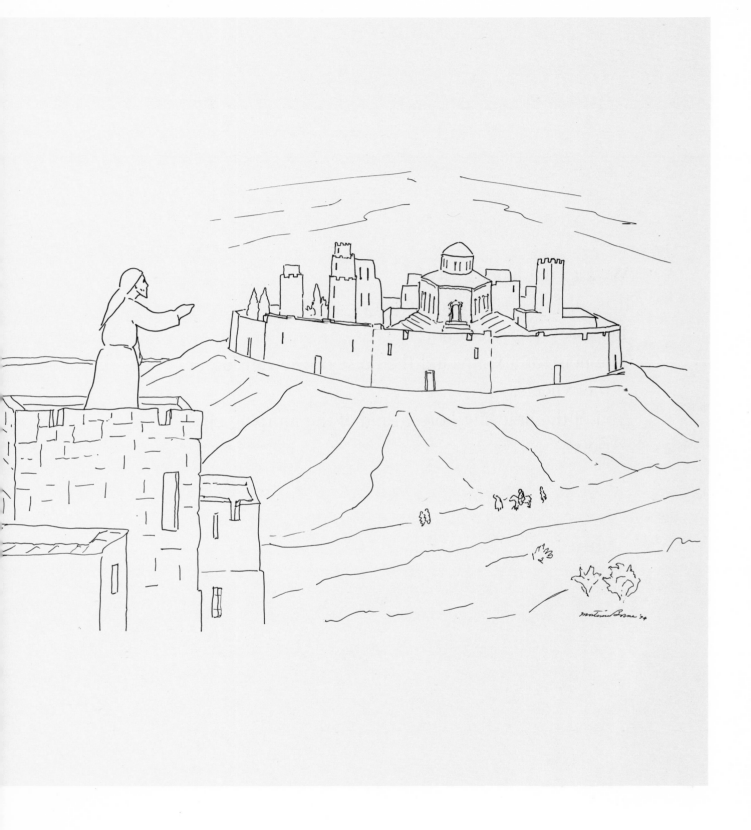

WOE to the bloody city!
It is all full of lies and robbery;
The prey departeth not;
The noise of a whip, and the noise of the rattling of
   the wheels,
And of the pransing horses, and of the jumping cha-
   riots.

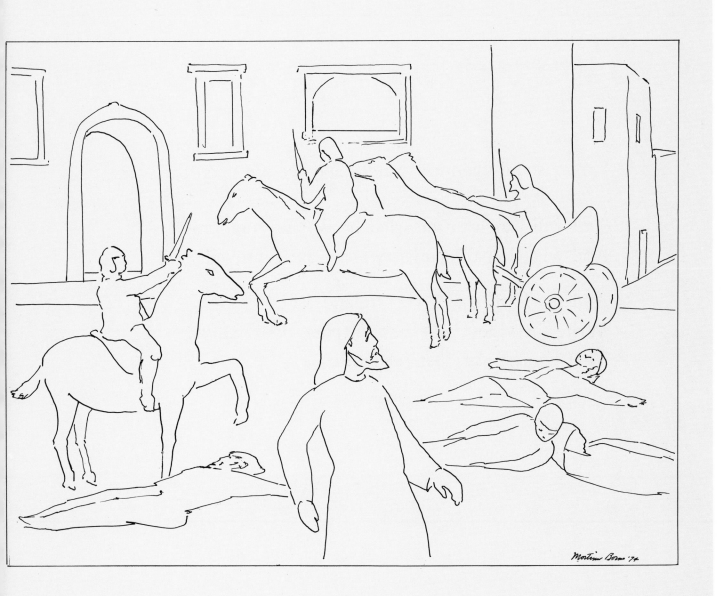

I WILL stand upon my watch, and set me upon the
  tower,
And will watch to see what he will say unto me,
And what I shall answer when I am reproved.

And the Lord answered me, and said,
Write the vision, and make it plain upon tables,
That he may run that readeth it.

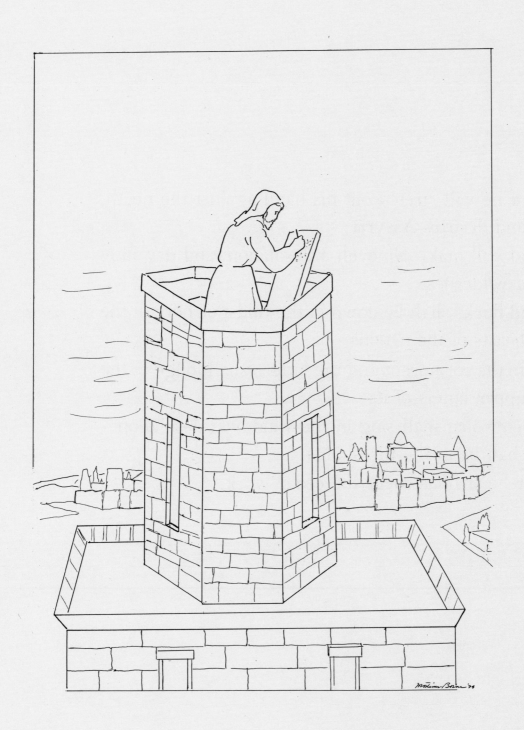

And he will stretch out his hand against the north,
    and destroy Assyria;
And will make Nineveh a desolation, and dry like
    a wilderness.
And flocks shall lie down in the midst of her, all the
    beasts of the nations:
Both the cormorant and the bittern shall lodge in the
    upper lintels of it;
Their voice shall sing in the windows; desolation
    shall be in the thresholds:
For he shall uncover the cedar work.

And again the word of the Lord came unto Haggai
in the four and twentieth day of the month, saying,
Speak to Zerubbabel, governor of Judah, saying,

I will shake the heavens and the earth;
And I will overthrow the throne of kingdoms,
And I will destroy the strength of the kingdoms
of the heathen;
And I will overthrow the chariots, and those that ride
in them;
And the horses and their riders shall come down,
Every one by the sword of his brother.

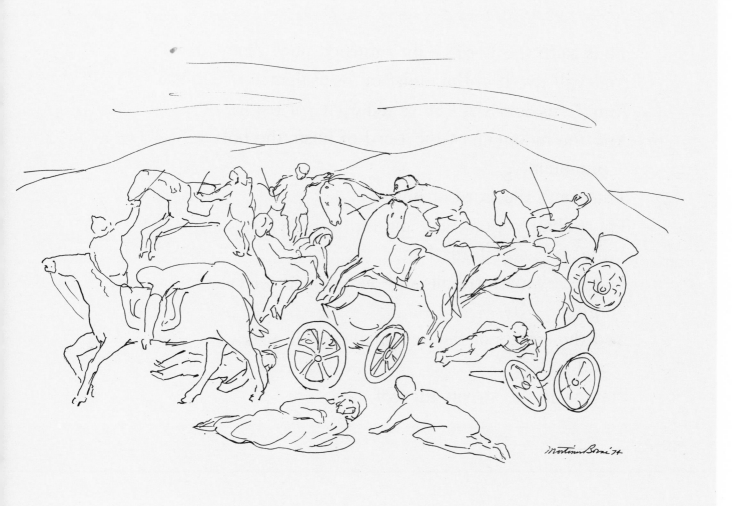

Thus saith the Lord; I am returned unto Zion,
And will dwell in the midst of Jerusalem:
And Jerusalem shall be called a city of truth;
And the mountain of the Lord of hosts the holy
   mountain.
Thus saith the Lord of hosts;
There shall yet old men and old women dwell in
   the streets of Jerusalem,
And every man with his staff in his hand for very
   age.
And the streets of the city shall be full of boys
   and girls
Playing in the streets thereof.

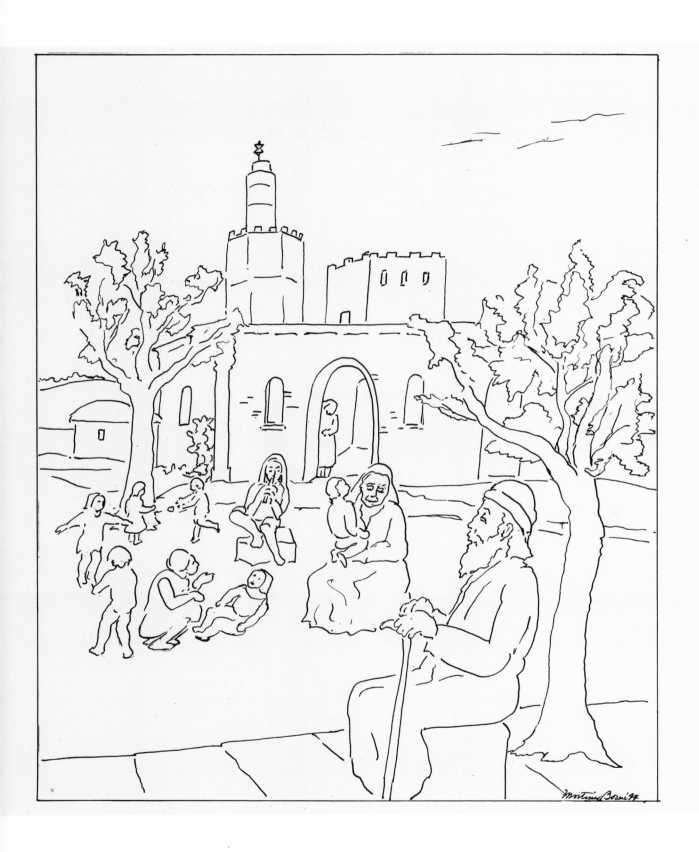

I have no pleasure in you, saith the Lord of hosts,
Neither will I accept an offering at your hand.
For from the rising of the sun even unto the going
down of the same
My name shall be great among the Gentiles;
And in every place incense shall be offered unto my
name, and a pure offering:
For my name shall be great among the heathen, saith
the Lord of hosts.

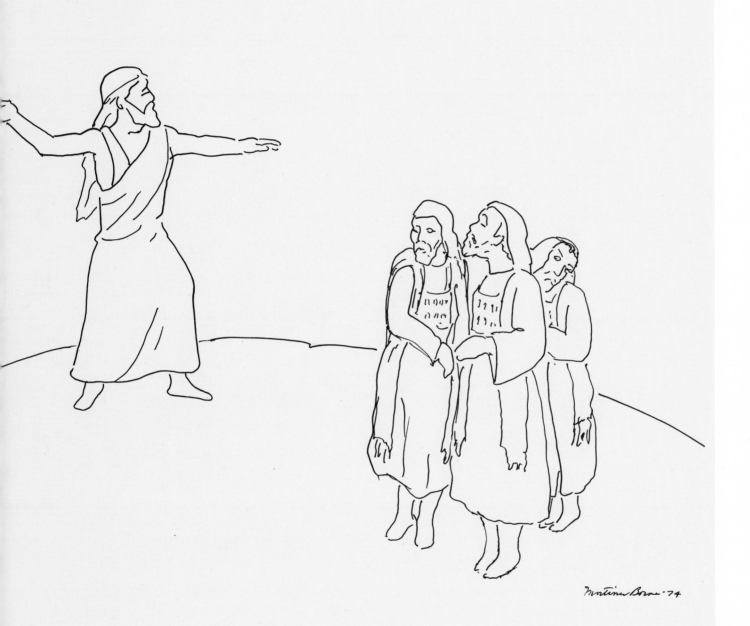

# WHO'S WHO
# IN AMERICAN ART

BORNE, MORTIMER
    Sculptor, Painter, Graphic Artist

ONE-MAN EXHIBITIONS

Jerusalem, Israel, 1935
Corcoran Gallery of Art, Washington, D.C., 1941
Museum of Fine Art, Montreal, Canada, 1942
Smithsonian Institution, 1944
Tel-Aviv, Israel, 1965
ETC.

GROUP EXHIBITIONS

Museum of Modern Art, New York
Metropolitan Museum
New York Public Library
Museum of Fine Arts, Houston, Texas (1976)
ETC.

WORKS IN PUBLIC COLLECTIONS

Metropolitan Museum of Art (more than 100 etchings and drypoints,
        black and white and color, dated 1926 and on)
British Museum
Museum of Fine Arts, Houston, Texas
Smithsonian Institution
Library of Congress
National Gallery of Art, Washington, D.C.
New York Public Library
Boston Public Library
Municipal Art Museum of Ramat-Gan, Israel
University of Judaism, Los Angeles
Bar-Ilan University, Ramat-Gan, Israel
ETC.

ARTICLES ABOUT AND BY MORTIMER BORNE

Numerous
A recent book: "The Visual Bible:Ninety-two Drawings by Borne", 1976.

MORTIMER BORNE  is the originator of : Color Drypoint; Chromatic Wood
  Sculpture; Convex Painting; and Constructive Woodcut.

BONNA, MORTIMER
Sculptor, Painter, Graphic Artist

ONE-MAN EXHIBITIONS

Jerusalem, Israel, 1935
Corcoran Gallery of Art, Washington, D.C., 1941
Museum of Fine Art, Montreal, Canada, 1942
Smithsonian Institution, 1944
Tel-Aviv, Israel, 1965
ETC.

GROUP EXHIBITIONS

Museum of Modern Art, New York
Metropolitan Museum
New York Public Library
Museum of Fine Arts, Houston, Texas (1976)
ETC

WORKS IN PUBLIC COLLECTIONS

Metropolitan Museum of Art (more than 100 etchings and drypoints, black and white watercolor, dated 1926 and on)
British Museum
Museum of Fine Arts, Houston, Texas
Smithsonian Institution
Library of Congress
National Gallery of Art, Washington, D.C.
New York Public Library
Boston Public Library
Montreal Art Museum of Beaux-Can, Israel
University of Judaism, Los Angeles
Bar-Ilan University, Ramat-Gan, Israel
ETC.

ARTICLES ABOUT AND BY MORTIMER BONNA

Numerous.
A recent book: "The Visual Bible:Two Drawings by Bonna", 1976.

MORTIMER BONNA is the originator of: Color Drypoint; Chromatic wood Sculpture; Canvas Painting; and Constructive Woodcut.

# WHO'S WHO
# IN AMERICAN ART

BORNE, MORTIMER
    Sculptor, Painter, Graphic Artist

ONE-MAN EXHIBITIONS

Jerusalem, Israel, 1935
Corcoran Gallery of Art, Washington, D.C., 1941
Museum of Fine Art, Montreal, Canada, 1942
Smithsonian Institution, 1944
Tel-Aviv, Israel, 1965
ETC.

GROUP EXHIBITIONS

Museum of Modern Art, New York
Metropolitan Museum
New York Public Library
Museum of Fine Arts, Houston, Texas (1976)
ETC.

WORKS IN PUBLIC COLLECTIONS

Metropolitan Museum of Art (more than 100 etchings and drypoints,
            black and white and color, dated 1926 and on)
British Museum
Museum of Fine Arts, Houston, Texas
Smithsonian Institution
Library of Congress
National Gallery of Art, Washington, D.C.
New York Public Library
Boston Public Library
Municipal Art Museum of Ramat-Gan, Israel
University of Judaism, Los Angeles
Bar-Ilan University, Ramat-Gan, Israel
ETC.

ARTICLES ABOUT AND BY MORTIMER BORNE

Numerous
A recent book: "The Visual Bible:Ninety-two Drawings by Borne", 1976.

MORTIMER BORNE is the originator of : Color Drypoint; Chromatic Wood
Sculpture; Convex Painting; and Constructive Woodcut.